IMAGES
of America

WILLIAMSON
COUNTY

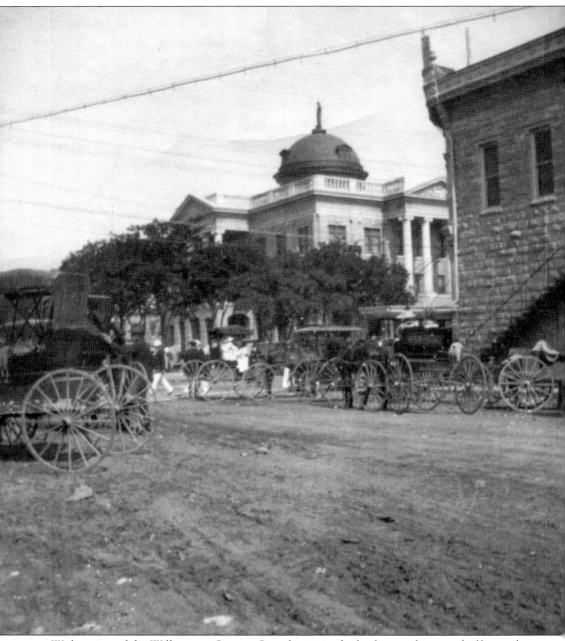

With a view of the Williamson County Courthouse in the background, a crowd of horse-drawn buggies park on an unpaved Seventh Street in Georgetown. The county seat, Georgetown has always been an important business and cultural destination for the surrounding communities. (The Williamson Museum Collection, 2006.021.009. Gift of George and Barbara Meyer.)

ON THE COVER: A couple walks past the Williamson County Courthouse in December 1912. This courthouse, the county's fifth since its establishment in 1848, was completed in 1911. (The Williamson Museum Collection, 2005.057.010. Gift of J. C. Johnson Jr.)

IMAGES
of America

WILLIAMSON
COUNTY

The Williamson Museum
Lisa E. Worley and Chris Dyer

ARCADIA
PUBLISHING

Copyright © 2009 by the Williamson Museum
ISBN 978-0-7385-7865-1

Published by Arcadia Publishing
Charleston SC, Chicago IL, Portsmouth NH, San Francisco CA

Printed in the United States of America

Library of Congress Control Number: 2009931123

For all general information contact Arcadia Publishing at:
Telephone 843-853-2070
Fax 843-853-0044
E-mail sales@arcadiapublishing.com
For customer service and orders:
Toll-Free 1-888-313-2665

Visit us on the Internet at www.arcadiapublishing.com

CONTENTS

Acknowledgments 6

Introduction 7

1. The County Seat and Government 9

2. Downtown Scenes and Businesses 19

3. Residences and Architecture 33

4. Agriculture 49

5. Education 69

6. Churches and Religion 87

7. Historical People, Places, and Events 105

Bibliography 126

Index 127

ACKNOWLEDGMENTS

The Williamson Museum gratefully acknowledges all who made it possible for us to produce this book, especially those who have donated photographs, information, and family histories over the years. Without their generosity, this project would have been impossible.

The images in this book are from the photographic collections of the Williamson Museum. Organizations and individuals that donated these images to the museum include the Williamson County Commissioners' Court, Williamson County Historical Commission, Southwestern University, City of Hutto Museum, W. D. Kelley Foundation, Nelson Homestead Family Partnership, Georgetown Heritage Society, Taylor Public Library, J. C. Johnson Jr., Dr. Doug and Nell Benold, Katherine Howland, Karen Thompson, Jerry Fleming, Gladys Queen, John Pavelka, John Jacob, W. C. Cantwell, Dorothy Bohac, Martin Parker, V. Vitek, Billy Ray Stubblefield, Harlan Hays, James and Hazel Hood, Leona Kieschnick Kokel, Stanley Schwenker, Velasta L. Miller, Lester Fisher, Clara Scarbrough, Joe Pekar, Dolores Volek, Ruth Olson, Martin and Lorine Anderegg, Flora Thompson, Hattie Cmerek, Dorothy Von Rosenberg, Rodney Johnson, Nancie Roddy, Danny Camacho, Connie Kanetzky, Miriam Kalmbach, Ruth Carlson, Margaret McCarn, Robert Rozacky, Larry Rydell, Jeanette Inglefield, Schwertner Family, Alice Zett, Frances Archer, Mary Mayes, John L. Bryson, Mary Hodge, Mary Ann Barbour, R. D. Love, M. Repa, Nina Zapffe, Mary Ella Prikryl, Yvonne and Howard Martin, Dana Noren, H. Stauffer, Phelonese Sledge, Dan Martinets, Joan Davis, John H. Lindell Sr., Norbert and Alvina Kaspar, Jack Pope, Mary Hughes Bass, Newton Calvin Holman, and Leslie Hill.

INTRODUCTION

The historical timeline of this area bulges with events that have shaped Williamson County's cultural landscape. As early as 13,000 years ago, people found their way here because of the countless, readily available resources, including fresh water, bountiful flora and fauna, and a favorable climate.

The Tonkawa, Comanche, and Apache tribes were the area's main residents through the early 1800s. French explorer Robert Cavalier Sieur de la Salle visited central Texas in the 17th century, and Spain's Aguayo Expedition crossed the Rio de San Xavier (San Gabriel River) in 1721. Williamson County's rich pioneer history started in earnest in the mid-1830s as American settlers began searching westward for new territory. In 1835, one of the first Texas Ranger companies, under the leadership of Capt. J. Tumlinson, constructed Block House Fort near present-day Leander. Dr. Thomas Kenney constructed Kenney Fort in Round Rock in 1838. In the mid-1840s, John Berry constructed one of the first gristmills in the county on the site of today's Berry Springs Park and Preserve.

Settlers successfully petitioned to form a new county out of the Milam District in 1848. Before then, people traveled almost 50 miles to transact county business at Nashville-on-the-Brazos. The Texas Legislature named the new county in honor of San Jacinto veteran, Texas Ranger, and judge Robert McAlpin Williamson.

Thomas B. Huling and George Washington Glasscock donated roughly 173 acres for a county seat, which was named Georgetown in Glasscock's honor. At that time, a large oak tree served as the meeting place for the first county court. This site, Founders' Park, is located at Ninth and Church Streets in Georgetown. Five courthouses followed, each fulfilling the growing needs of the county. The current courthouse, constructed in 1911, was restored in 2007.

In the 1870s, German, Austrian, Swiss, and Wendish immigrants began to arrive. Swiss families established New Bern, and the German-Wends settled Walburg. German-Austrians spread out to a number of communities, including Corn Hill, Theon, and Thrall. Small numbers of Danish and Norwegian immigrants moved to Frame Switch and Hutto. Some French families settled in Monodale and Sandoval. Czech, Morovian, and other Slavic groups arrived in Williamson County in the 1880s and 1890s and established Granger, Machu, and Mozo. As European immigration slowed in the 1910s, large numbers of Hispanics arrived. Ethnic groups who stayed in Williamson County brought rich cultural traditions with them and established new customs in their adopted homes.

At the start of the Civil War, Williamson County was one of only three Texas counties to vote against secession. Despite this, Williamson County citizens formed at least five companies to support the Confederate war effort.

Following the war, demand for Texas beef spiked. Entrepreneurial families, including the Snyders, Clucks, Olives, and Kuykendalls, rounded up longhorn cattle and drove them to distant railheads. The arrival of railroads to the county in the mid-1870s brought an end to the cattle drives.

Education and community life have long been paramount in Williamson County. In 1854, the county court organized 14 school districts. Southwestern University in Georgetown, one of the earliest private universities in Texas, was chartered in 1875.

Dan Moody, Texas's youngest governor to date, was born in Taylor. In the 1920s, Moody and his legal team successfully prosecuted the Ku Klux Klan.

Other notables include international rodeo star William "Bill" Pickett and civil rights advocate Dr. James Lee Dickey. Pickett worked on ranches in eastern Williamson County before going on to fame; he is generally credited with inventing the sport of bulldogging. In the 1950s, Dickey halted a typhoid epidemic and was named Taylor's Citizen of the Year.

This is just a snapshot of events, places, and people in Williamson County's past. Whether you have just moved to the county or have lived here all your life, we encourage you to grab a map and hit the area's scenic roads to soak up Williamson County's fascinating history.

One

THE COUNTY SEAT
AND GOVERNMENT

Shortly after Texas won its independence from Mexico in 1836, settlers established county governments, and the need for centralized meeting places became apparent. Throughout Texas, the county seat and its central courthouse filled this role, becoming the symbol of independent self-government in Texas.

Early pioneers in the western portion of the Milam District followed this trend towards autonomy by petitioning to create Williamson County in 1848. The petition was approved, and that same year, Georgetown was established as the Williamson County seat. In 1849, the new county acquired its first courthouse.

Williamson County's courthouse served as a place to conduct legal and social business. Over the years, the county moved into a larger structure in 1851, and then built its first dedicated courthouse in 1857. As the population and wealth of many Texas counties increased in the late 1800s, the need for larger structures resulted in a statewide courthouse boom. Williamson County led the charge, erecting an elaborate new Victorian courthouse in 1878.

The current Williamson County courthouse, built in 1911, has survived three major renovations and many modifications—including the demolition of its key architectural features in 1966. Assisted by the Texas Historical Commission, preservation-minded county citizens and officials restored Williamson County's fifth courthouse to its original 1911 splendor, making it a focal point of the county once again.

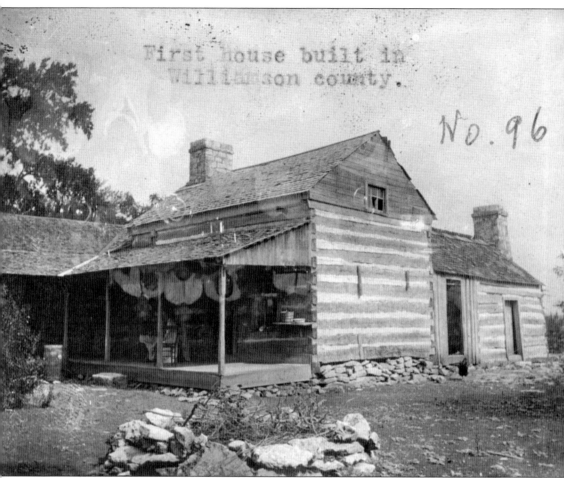

After citizens of western Milam District circulated a petition in 1848, the Texas Legislature created Williamson County, named after Robert McAlpin Williamson. Elections were quickly held and the new county commissioners met to find a location to establish a county seat. George Washington Glasscock and his silent partner, Thomas B. Huling, donated land for what would become Georgetown. Before those first county officials acquired a building to serve as a courthouse, they met under an old oak tree at the corner of Ninth and Church Streets. The county purchased a log cabin similar to this one to serve as the first county courthouse in 1849. Originally located just east of the present-day courthouse square, the county court used the log structure until May 1851.

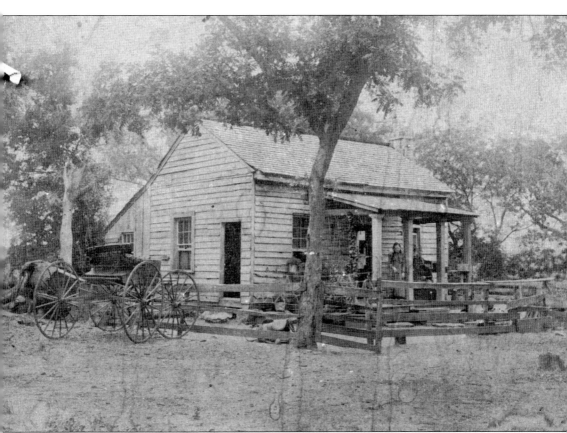

In May 1851, the county purchased a house (above) from William Patterson to serve as the second courthouse. Located east of the courthouse square, at Church and Eighth Streets, this structure offered double the space of the previous courthouse. However, as county business continued to expand, even more room was needed. The county made plans to construct a third courthouse: a two-story, 50-foot-square building with thick stone walls. Joseph W. Williams drew the plans, and the initial contract to construct the building for no more than $5,000 was awarded to John Dunlop. After contractual and legal difficulties, the county turned to Evan Williams to complete the building, which he did in 1857. This courthouse was the first constructed on the courthouse square. No known images of this building exist.

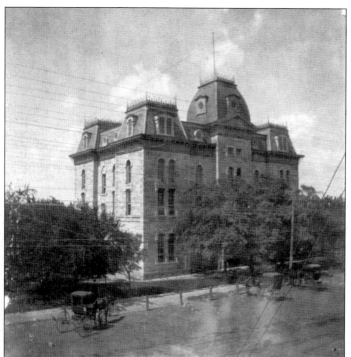

From the beginning, the third courthouse suffered substantial structural problems, and it was deemed unstable after only 20 years. In 1877, county commissioners voted to erect a fourth courthouse for Williamson County. They purchased ready-made plans from Austin architects Jasper N. Preston and Frederick E. Ruffini. With a bid of $27,400, John Didelot won the contract to construct the new Second Empire–style building.

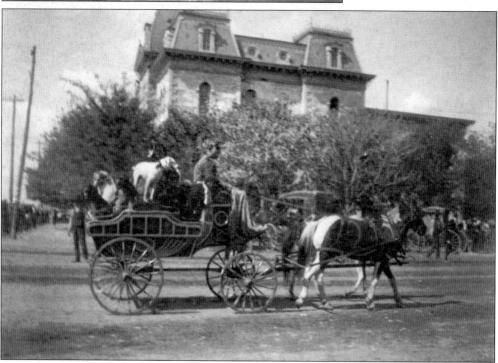

Annie Whittenberg Sharpe took photographs of a parade in front of the fourth courthouse when Gentry's Trained Animal Show came to town, around 1902. Whether for social or political reasons or for entertainment, the courthouse square has always served as the center of activity for Williamson County residents.

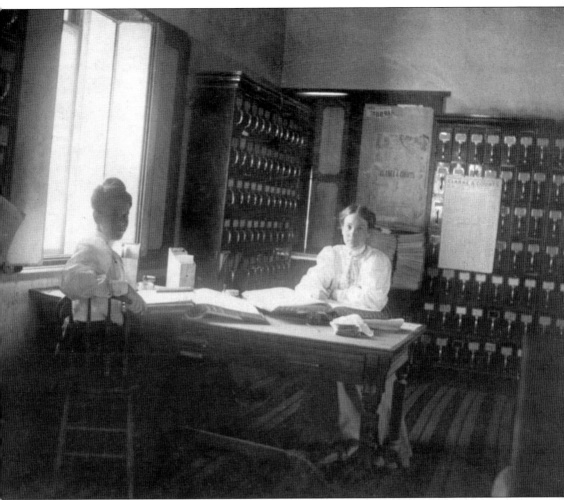

County officials moved into the newly completed fourth courthouse in September 1878. This new structure provided much more space than any of its predecessors. With its mansard roof and tall Italianate windows, the fourth courthouse was the epitome of Victorian architecture. Architects Preston and Ruffini shopped ready-made building blueprints to various counties, and a number purchased the plans. Consequently, numerous courthouses found in the region today resemble Williamson County's fourth courthouse. The Preston and Ruffini–designed building served the county and its citizens until 1909. After deeming the courthouse dangerous, the county held a bond election for approval of $120,000 in funds to construct a new courthouse and razed this one. The unidentified women in this image are employees of the county clerk's office. The calendar in the photograph reads "1906."

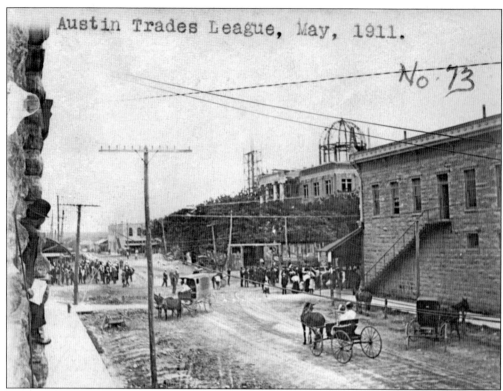

Construction of the county's fifth courthouse began in March 1910. Architect C. H. Page and Brother of Austin designed the building with massive paired columns, projecting facades, balustrades, and detailed pediments typical of the Beaux-Arts style. Page and Brother also designed courthouses in Anderson, Fort Bend, Hays, Hunt, and Orange Counties. In October 1910, the cornerstone was laid, and the courthouse was ready for use in November 1911. These two images were taken around May 1911. They show the framework of the courthouse's dome, then under construction.

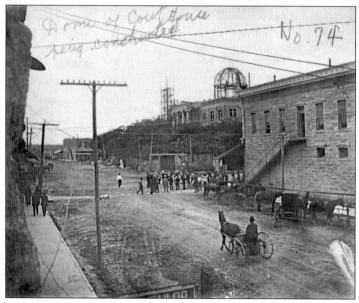

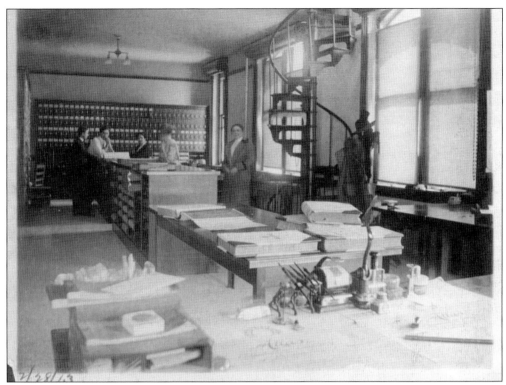

The Texas Constitution established the office of county clerk in 1836, making it one of the oldest governmental offices in the state. The county clerk's office is responsible for recording and maintaining a variety of legal documents, including birth and death certificates, deeds, cattle brands, and various types of business licenses. These two images were taken on February 28, 1913, a year after county officials accepted the newly completed courthouse. Charles McMurray served as the county clerk from 1912 to 1918. These images show the men and women who worked under McMurray in the records room.

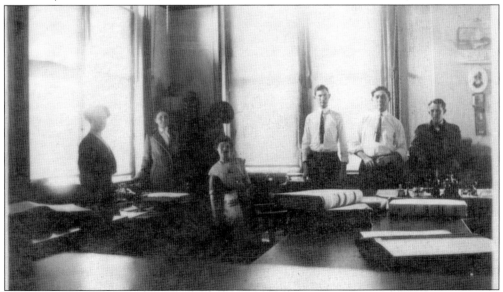

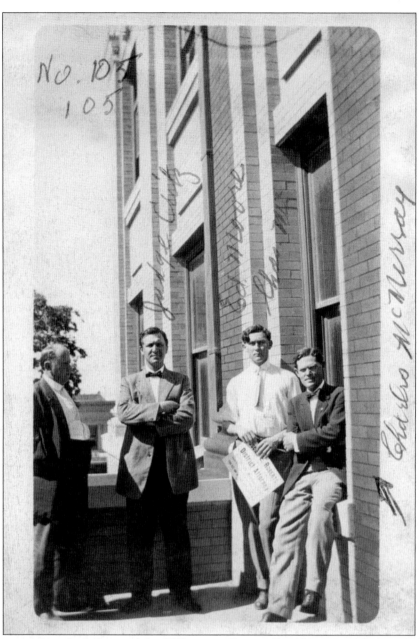

Four men stand on the balcony of the Williamson County Courthouse on May 10, 1912. From left to right are an unidentified man; Judge Richard Critz, Williamson County judge from 1910 to 1918; Ed Moore; and Charles McMurray, Williamson County Clerk from 1912 to 1918. Judge Critz oversaw the razing of the fourth courthouse and completion of the current one. Critz practiced private law in Georgetown after serving as the county judge. While in private practice, he assisted Dan Moody in the prosecution of members of the local Ku Klux Klan chapter in 1923. After Moody became governor, he appointed Critz to the Commission of Appeals to the Texas Supreme Court in 1927. In 1935, Gov. James Allred appointed Critz an associate justice of the Texas Supreme Court. Critz served in that capacity until 1944, when he lost reelection and returned to private practice.

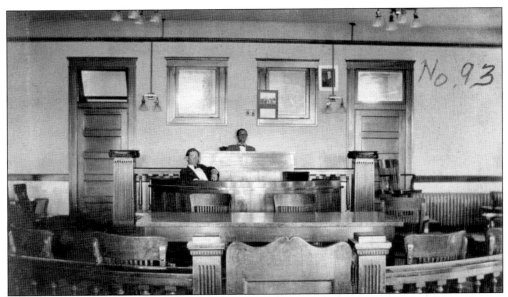

The Williamson County Courthouse's restoration was completed in December 2007, and many of the county's offices moved back into the building. The county commissioners continue to conduct the county's business, including administration and budgeting, county road and bridge maintenance, and setting tax rates, in this historic room. This photograph was taken in the county commissioner courtroom on May 12, 1912, just two months after the county accepted the completed building.

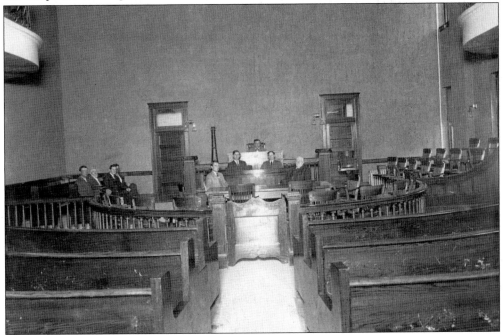

While court cases are no longer heard in this courtroom, one of the state's most famous trials was held here. In 1922, district attorney and future governor Dan Moody and a team of lawyers successfully prosecuted local members of the Ku Klux Klan for flogging a man. Moody's fame from the trial helped propel him to state office.

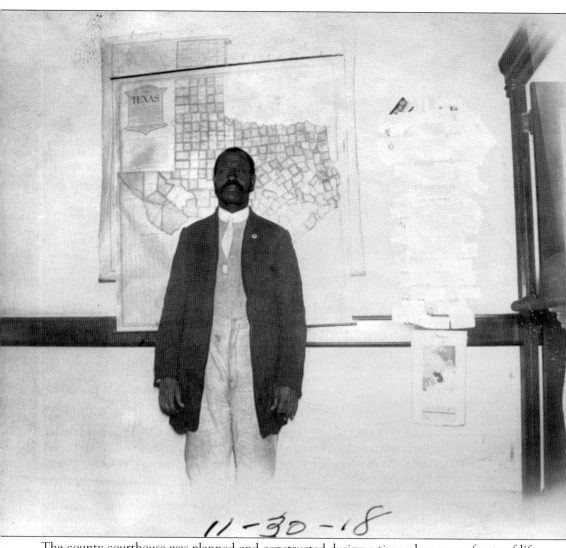

11-30-18

The county courthouse was planned and constructed during a time when many facets of life were segregated based on race. The Williamson County Courthouse had separate bathroom facilities for black and whites. For African Americans, a water fountain with an outdoor-style spigot located in the rotunda on the first floor was clearly marked "Colored" until 1965, when Judge Sam Stone ordered the signs painted over. This photograph dates from November 30, 1918, and shows the courthouse's janitor. While nothing is known about the man shown, it is interesting to note that women's suffragist Jessie Daniel Ames wrote in a letter dated June 13, 1918, that after the recent election, the county "has been cleaned up from the Legislators to the Janitor in the Court House."

Two

DOWNTOWN SCENES AND BUSINESSES

Whether just a few buildings, a strip of businesses, or a square in layout, downtowns have served as the heart of commerce, political activity, entertainment districts, and gathering places for Texas communities. From brick-paved streets to limestone facades, Williamson County has an abundance of historic communities, each with unique downtown centers and businesses.

Of the more than 70 communities founded in Williamson County since 1848, many have since declined, moved, or been incorporated into the larger cities of Round Rock, Georgetown, Cedar Park, and Taylor. It is difficult to accurately establish how many separate communities exist in Williamson County today; however, historian and author Clara Stearns Scarbrough identified 33 communities in her 1970 book *Land of Good Water*. By 2004, the county consisted of 11 communities with populations over 1,000 people and 7 cities with populations of over 5,000.

Over the years, drought, flooding, war, recession, and the decline of the cotton industry all struck blows to Williamson County. While some communities thrived, others like Corn Hill, Mozo, and Peyton vanished as the result of the bypassing railroads, the crashing cotton industry, and recurring, catastrophic natural disasters.

The first half of the 20th century weighed hard on the county's communities, specifically their businesses. Once hubs of activity, many downtowns sat quiet and mostly abandoned until the 1980s. Luckily, with the dedicated work of residents and the help of the Texas Main Street Program, communities like Taylor and Georgetown have bounced back and look much as they did in their heyday. Towns like Walburg, Weir, Granger, and Coupland remain small but successful. Businesses once again seek downtown locations to capitalize on the charm of Williamson County's historic locations.

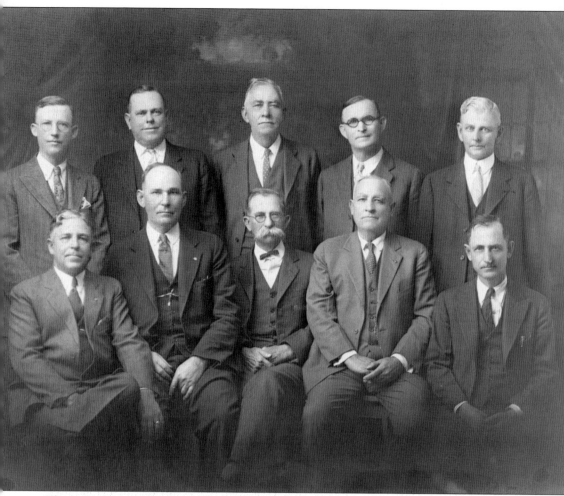

This *c.* 1925 image shows 10 of Williamson County's most influential businessmen, landowners, investors, and bankers who helped make the area's various communities prosperous. From left to right are (first row) Owen W. Sherrill (president of City National Bank), E. H. Eanes (vice president of First National Bank), J. E. Cooper (president of First National Bank), E. M. Daughtrey (financier), and John M. Sharpe (editor of the *Williamson County Sun*); (second row) W. L. Price (vice president of Farmers State Bank), Tom E. Nelson (banker, plantation owner, and financier), E. G. Gillette (president of Farmers State Bank of Georgetown and treasurer of Southwestern University), H. H. Onstot (vice president of City National Bank), and Carl A. Nelson (president of Farmers State Bank in Round Rock).

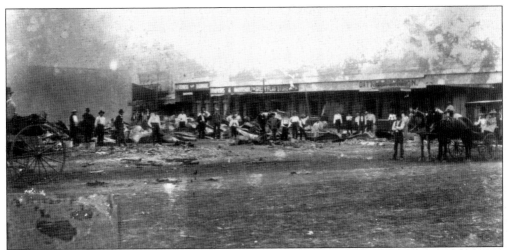

This photograph, taken around 1900, shows East Street in Hutto. A large fire in Hutto in 1902 destroyed many of East Street's commercial structures. A gasoline-stove explosion in Jackson Restaurant started the blaze. Fires wrecked havoc in Williamson County at the turn of the century, including a 1909 fire that decimated a large portion of Bartlett.

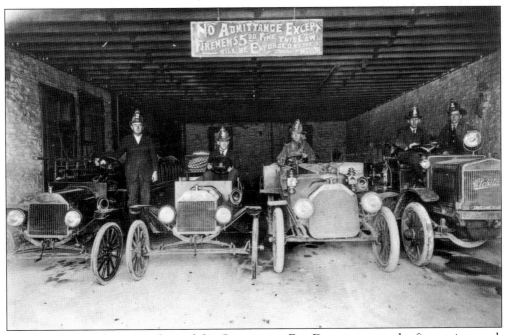

This photograph shows members of the Georgetown Fire Department at the fire engine truck house. R. O. Davis (second from left) later became fire chief. The historic Georgetown Fire House and City Hall building located on Main Street in Georgetown is one of the few remaining examples of a 19th-century combination city hall and fire station still standing in Texas. The Texas Historical Commission has named the structure a Texas landmark.

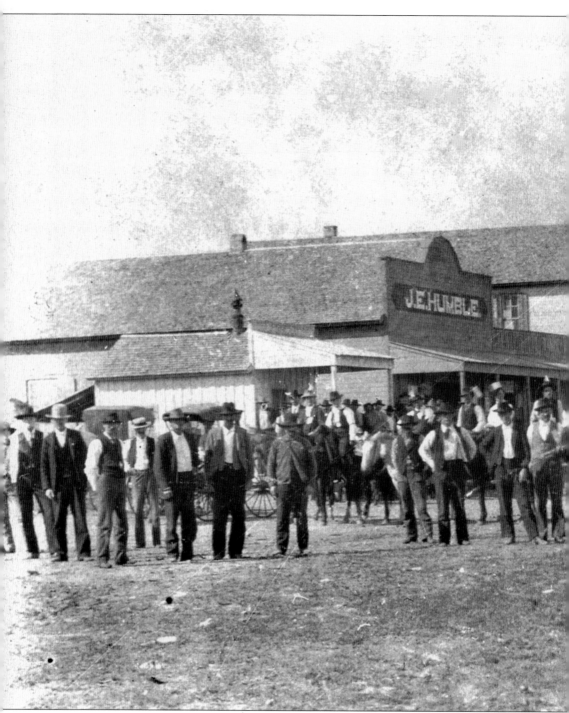

When the Austin and Northwestern Railroad bypassed the town of Bagdad in 1882, a new community called Leander sprang up a mile to the east. This image of Leander shows the town around 1890. The new community was named after railroad official Leander Brown. Bagdad, established much earlier in 1854, had experienced a great deal of success leading up to arrival of the railroad. When the railroad passed them by, citizens adjusted quickly. The Bagdad Post Office

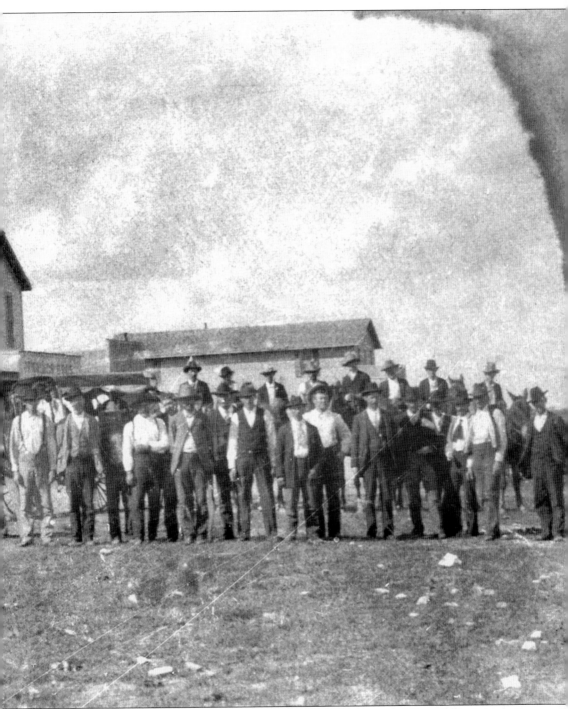

moved to Leander in 1882, and many of the former Bagdad businesses followed suit. Leander's commercial businesses, cedar post industry, and farming and ranching operations all prospered because of the railroad. Today Leander boasts the largest school district in Williamson County and has an estimated population of over 30,000 people.

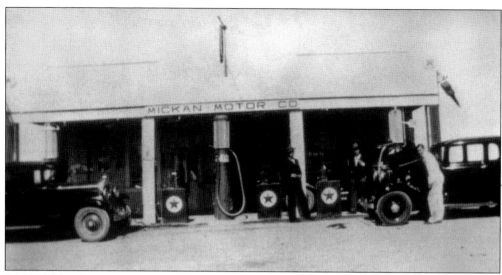

By 1930, the Texas Highway Department reported almost 12,000 registered automobiles in Williamson County. Until the 1930s, Williamson County roads were poor, and crossings were treacherous. As the decade progressed, the county paved main thoroughfares, constructed bridges, and straightened roadways. As the demand for gasoline-powered transportation increased, so did the businesses that supported it. Before long, almost every downtown in Williamson County boasted a full-service station where drivers could purchase gasoline and have their automobile repaired. Daniel Mickan founded the Mickan Motor Company of Walburg (above in the 1930s) in 1927. This business has been owned and operated for over 80 years by three generations of the Mickan family. The image below shows an unidentified man repairing a flat tire at Krieg Brothers Chevrolet Company in Thrall around 1935.

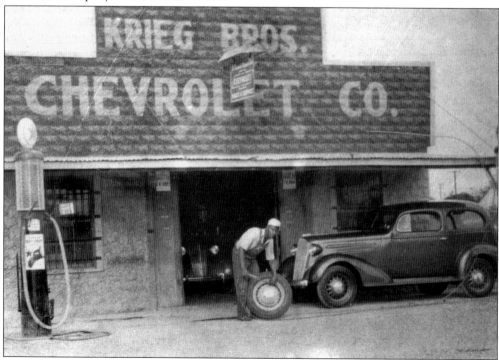

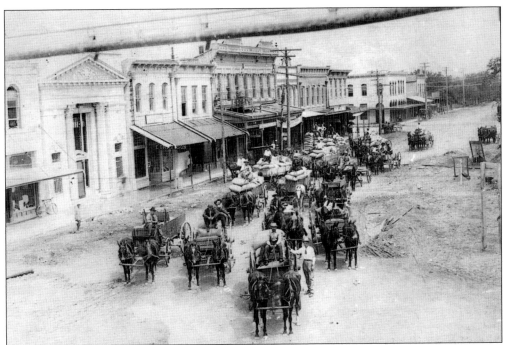

This c. 1915 photograph shows the Behrens family headed south through Georgetown on Austin Avenue with their fleet of mule- and horse-drawn cotton wagons. Those in the photograph (order unknown) include H. J. Behrens, Edward Behrens, August Behrens, Adolph Behrens, Emile Behrens, and Ben Behrens. The Farmers State Bank, shown at the top right corner, was established in 1912 and served the banking needs of patrons until the 1960s. The cotton industry in Williamson County in the late 1800s resulted in the establishment, growth, and economic prosperity of many thriving downtowns and communities. The image below shows the public square around the courthouse. Williamson County led all Texas counties in cotton production in 1899, producing over 89,000 bales.

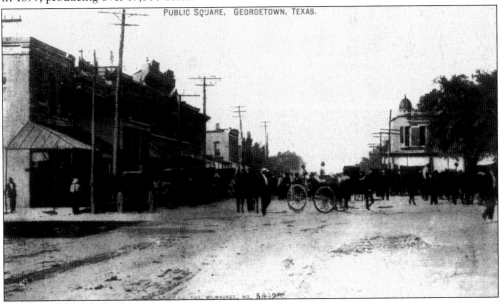

Williamson County's downtowns serve as business districts and as hubs for social activity. This photograph shows a Fourth of July parade on Main Street in Taylor around 1920. The cupola of Taylor's former city hall is visible in the center of the image. For many years, the city hall building, razed in 1935, served as a gathering place for social, entertainment, and political events in Taylor.

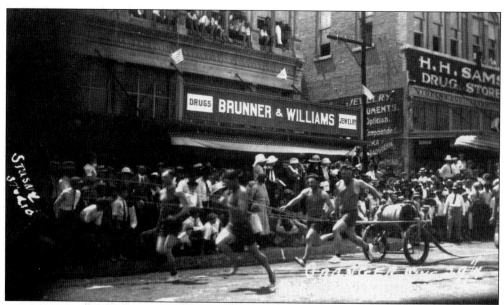

For many years, almost every Williamson County community hosted parades, county fairs, and other organized events that would attract people from surrounding areas. The Taylor Fourth of July parade and event was noted for its beauty pageant and various competitions with nearby towns. One favorite event was the match-up between the Granger and Taylor fireman racing teams, shown here in 1922.

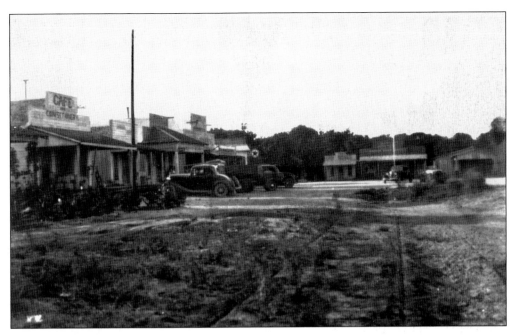

The above image shows a 1930s view of downtown Andice. At that time, Andice's population was estimated at 150 residents. Andice was originally called Stapp after Joshua Stapp, who settled in the area in 1857 and constructed a log building to serve as a church and school. Resident William Newton later applied for a new post office for the area in 1899, hoping that it would be named after his son Audice. His post office application was granted, but mistakenly under the new name of Andice. The photograph below shows Milton Love and his wife with their horse-drawn wagon in front of Gus and Ben Jacob's Red and White Store around 1932. The store served area residents and travelers from the early 1930s until the 1970s.

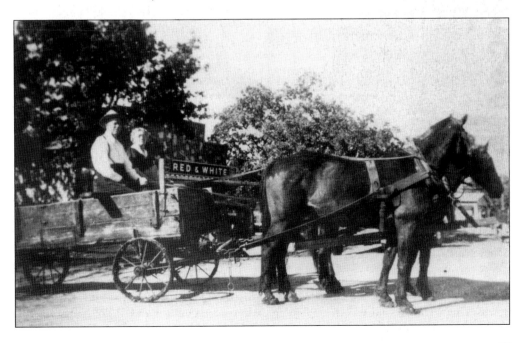

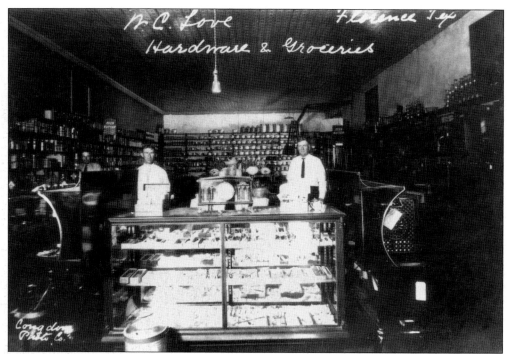

The above 1890s image shows the interior of the William Chapman Love Hardware and Grocery Store in Florence. The close of the 19th century marked a prosperous time for many Williamson County communities, Florence included. At that time, Florence had a strong ranching industry and a growing downtown with many successful businesses, including retail stores, grocers, photographers, doctor's offices, mills, churches, a college, a newspaper office, a blacksmith shop, hotels, a bank, restaurants, a tailor shop, and even a cheese factory. Acme Tailor Shop, shown below, helped Florence residents with all of their clothing needs. This photograph captures Ozias Cantwell (standing, right) hard at work.

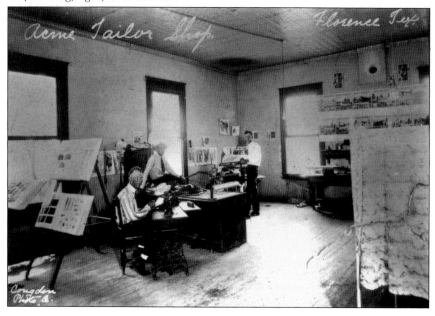

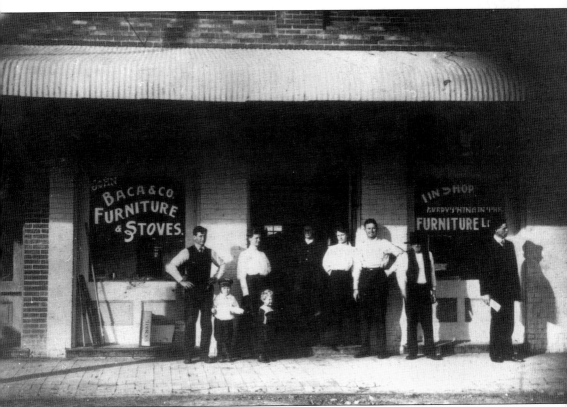

The Granger and Taylor areas were centers for Czechoslovakian immigration in Williamson County in the 1880s and 1890s. Many of these early immigrants found the land in the eastern portions of the county affordable and ideal for farming and starting businesses. Teresie Muzny Bohac was the daughter of Moravian parents who immigrated to Dublina, Texas. In 1902, after the death of her husband, she came to Granger with her six children, Frances, Henry, Ludwick, Edmund, Jim, and John. Bohac opened the Baca and Company Furniture and Stove Store in Granger around 1908 with business partners and family members John F. Bohac, Frances Bohac Baca, and John Baca. Bohac and her children were all involved in the framing and furniture business in Granger for many years. Shown from left to right are John F. Bohac, Martha Bohac, Aloisa Neusser Bohac, Josef Bohac, Teresie Muzny Bohac, Frances Bohac Baca, John Baca, and two unidentified individuals.

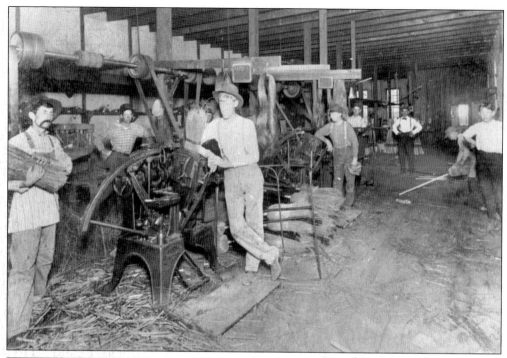

Round Rock boasted some very unique businesses that helped the local economy over the years, especially during the decline of the cotton industry in the late 1800s and on through the Great Depression. The Round Rock Broom Factory, located on Mays and Main Streets in Round Rock, was established in 1876 and operated until 1912. The image above shows a crew at work in the factory.

Louis Vitek, shown at left, drove a milk truck for the Round Rock Cheese Factory in the 1950s. Entrepreneurs Thomas E. Nelson and Elmer Cottrell opened the Round Rock Cheese Company in 1927 on Georgetown Avenue. The business proved to be extremely successful, and ultimately the Armour and Swift Company bought it. The factory, operating through the 1960s, purchased milk locally for cheese production, providing a welcome source of income for area farmers.

Originally located 3 miles to the west in 1853, Liberty Hill's first settlement had its own post office. The town acquired its name after postmaster William Oliver Spencer suggested it. Local lore states that Texas senator Thomas Jefferson Rusk stopped at the Spencer home on his quest to find locations for post offices. At that meeting, it is believed that Spencer and Rusk named the town Liberty Hill because of its location on a hill and for the independent character of the people in the area. In 1882, the Austin and Northwestern Railroad bypassed the town, but resilient citizens relocated nearer the rail line. In 1896, Congress added free rural mail delivery to the railroads, enabling mail carriers to reach the most remote areas. With the mail came the first Sears and Roebuck catalogs, for which the farmers originally paid just 10¢. These catalogs, however, competed for business with the local general stores that stocked, or could order, just about anything a customer might need. In the photograph above, Miller A. Stubblefield is shown working the counter at the W. O. Stubblefield Store in Liberty Hill around 1918. The Stubblefield Store later became the O. O. Perry Store.

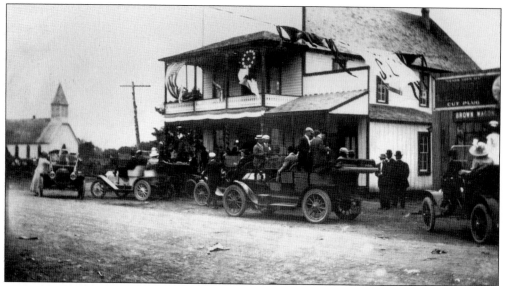

The Jonah community emerged in 1857, when Joseph Mileham and James Warnock constructed a mill on the San Gabriel River east of Georgetown. Residents applied for a post office under the names "Water Valley" and "Parks," but both were rejected because other Texas post offices already existed under those names. The name "Jonah" was accepted in the 1880s, and the community officially formed. This downtown view shows Percy's Store and Jonah Methodist Church around 1910.

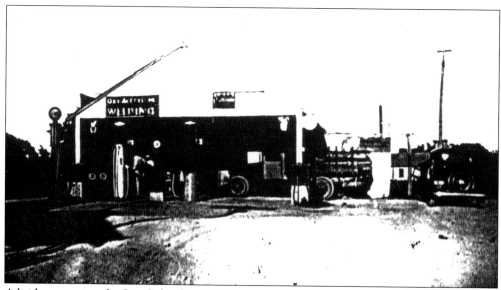

A bridge spanning the San Gabriel River in Jonah was dedicated in July 1904, providing a much needed and more dependable option for traversing the river. This bridge opened a new route for travelers on foot, horseback, and eventually via automobile. The above photograph, taken in the 1920s, shows Homer Hood standing in front of his service station and garage in Jonah.

Three

RESIDENCES AND ARCHITECTURE

Some say that home is not a place, but people. In Williamson County, it is both. Almost every community in Williamson County, regardless of its size, has tree-lined neighborhoods with an abundance of historic homes and associated buildings in a wide range of architectural styles. In a few locations, the earliest of these still stand, their historic importance recognized and cherished as a reminder of the first pioneers. These surviving vestiges of the first settlers in many cases have continued to serve third- and fourth-generation county citizens. Juxtaposed to these aged buildings stand pristine examples of later styles, including Colonial Revival, Italianate, and arts and crafts, among others.

Some notable builders and architects, both local and hailing from all over the state, helped shaped the design, layout, and character of Williamson County's architecture—residential, commercial, and governmental. They include C. H. Page and Brother, who designed the county courthouse and the Farmers State Bank in Georgetown; the Belford Lumber Company, which was responsible for homes in Georgetown; A. S. Robertson; Robert S. Hyer; William Flick; Henry Struve; and A. W. Carpenter and S. M. Woolsey, who constructed numerous buildings in downtown Hutto. The quality and craftsmanship remains evident in the historic neighborhoods of Williamson County that residents continue to call home today.

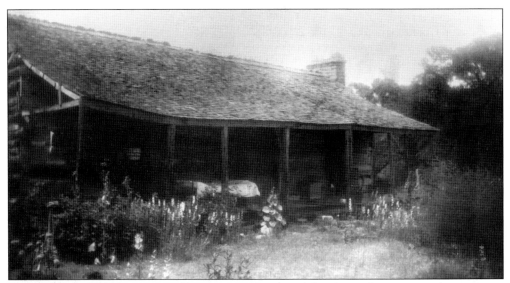

Rural domestic buildings are usually constructed to meet lifestyle needs, not an aesthetic vision. Commonly, future occupants and not professional architects designed and constructed the area's first wood-frame homes, and these were built to shelter their families against the elements, not to mimic current architectural fashions. Nonetheless, the farmers' pragmatic placement of doors, windows, and porches—designed to provide comfortable living in all seasons—created a style of its own. These two images show examples of simple, wood-frame residences from Williamson County. The above image, taken around 1937, shows the Adam C. Miller home, which was located on the San Gabriel River near Liberty Hill.

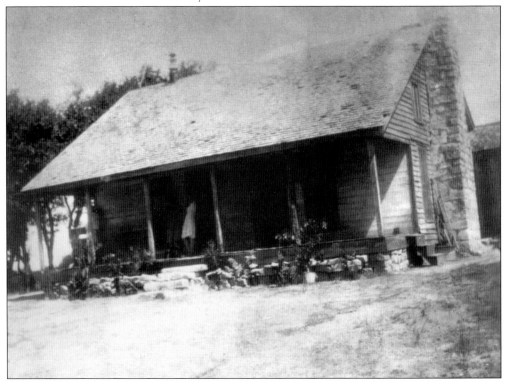

The early settlers to Williamson County usually constructed simple log cabins or wood-frame buildings as their first homes. Once they established themselves, and as increased finances would allow, many families built larger, more elegant homes. The Kokels moved to the Walburg area and initially lived in this simple wood-frame house with a stone chimney (right). Later the family moved into the much larger home shown below. Common in New England from 1830 to 1850, the popularity of this style of home spread to the American Southwest as the railroad expanded across the continent.

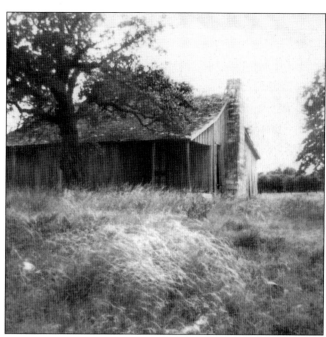

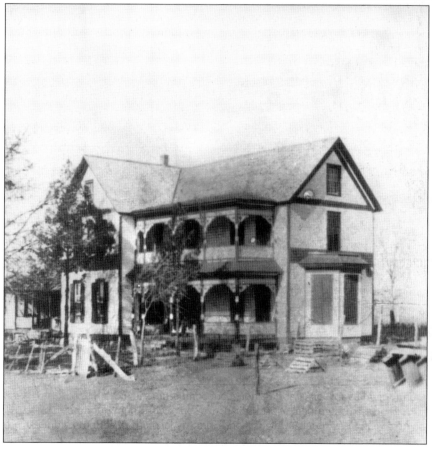

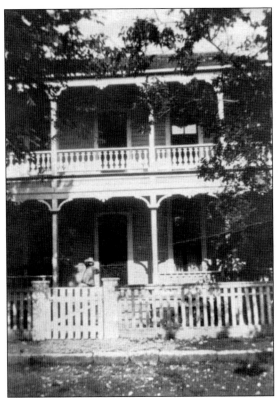

This house at 1222 Main Street in Georgetown was the first built on the street. William Fleager purchased the property in 1883, around the same time the residence was built. His daughter, Rosell Whittenberg, inherited the home upon Fleager's death in 1893 and owned the property until her own death in 1928. The Victorian Italianate-style house's front facade originally featured upper and lower gallery porches. These images were taken around 1910 and show the house before the porches were removed in a 1930 renovation.

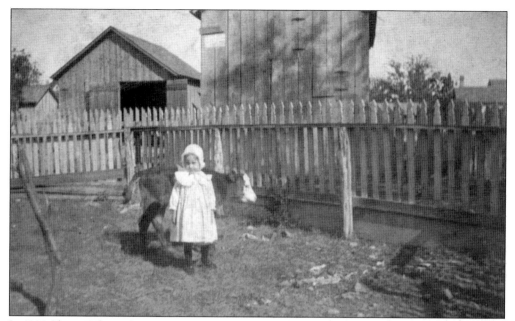

In 1901, Pharis Whittenberg stands in her grandmother's backyard (1222 Main Street, Georgetown) with a small calf. At the turn of the century, even town families continued to keep animals and grow crops to sustain their daily life. Note the outbuildings in the background.

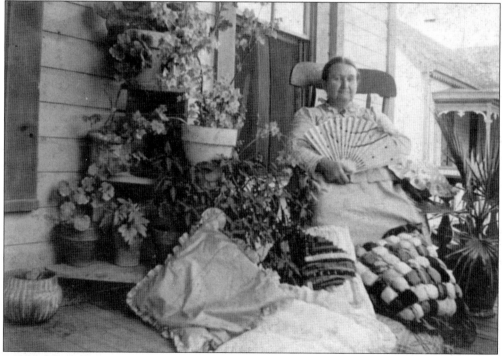

Before air conditioning, the placement of windows, doors, and porches were all-important as Texans grasped for ways to live with the summer's heat and humidity. When weather permitted, they used porches as extensions of their living quarters. In 1904, Rosell Fleager Whittenberg sits on the porch outside the family home in Georgetown, rocking and fanning herself.

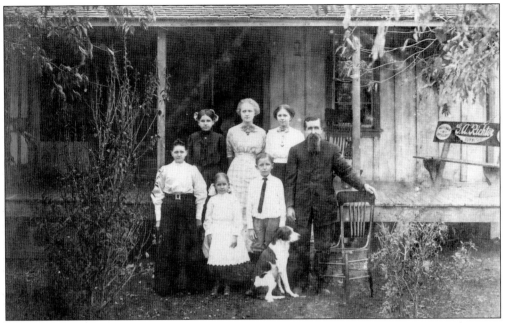

Owners of a pharmacy in Taylor, the Schwenker family stands in front of their wood-frame home in Wuthrich Hill around 1918. Members of the family (some pictured here) include Lillie Schwenker, Carrie Schwenker, Mrs. Henry Schwenker, Henry Schwenker Jr., and Henry Schwenker. In 1894, Henry Schwenker and other men formed a Lutheran association in Wuthrich Hill to organize the Evangelical Lutheran St. James Congregation. Prior to that time, residents of the Wuthrich Hill area attended services in Taylor.

The home of Dr. Anton C. and Marie Mussil exhibits typical folk Victorian detailing, from its L-shaped floor plan to its tall windows with decorative pediments. This architectural style, popular from 1870 to 1910, spread across the United States with the railroad, which came to Granger in 1882. In this picture, taken in January 1926, the Mussil children, Velasta, Theodore, and Lollie, play in the snow in their front yard.

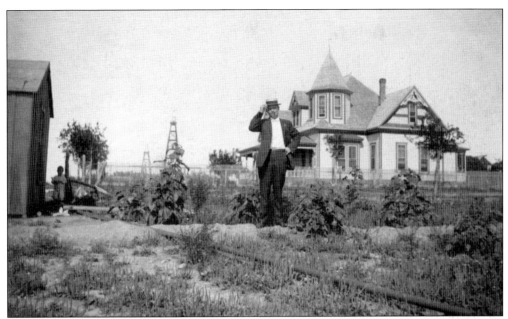

The settlement of Stiles Switch began in 1876 as a station for the International and Great Northern Railroad. Originally named for the family that owned a ranch where the station was located, the Stiles family chose to rename the community Thrall after a minister and historian they admired, Homer S. Thrall. A farming and cattle community, Thrall gained wealth and fame in 1915 when locals discovered oil on their lands (below). During the boom, over 300 oil wells were dug, and the population rose to 3,000. The image above was taken on May 19, 1915. It shows a man standing in front of a large, new house with two oil derricks in the distance. Thrall's oil boom lasted until only about 1920. The town experienced a brief resurgence in 1930 with another small oil boom, but it did not have the same impact as the earlier one.

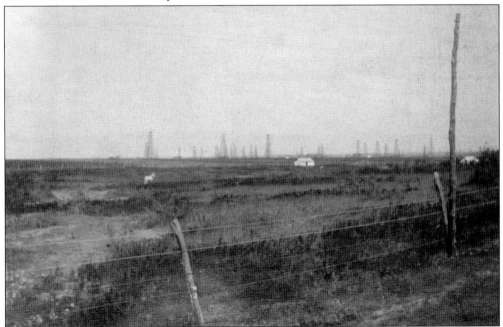

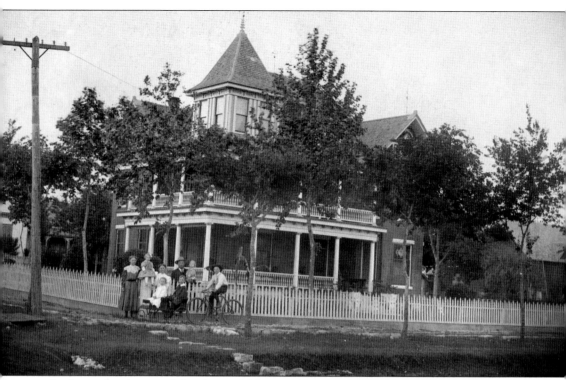

In this undated image, John August Nelson and his family stand outside their home in Round Rock. The grandson of Arvid and Anna Lena Nelson, early emigrants from Sweden, J. A. Nelson built this house on the northeast corner of Main and Stone Streets. It was considered one of the grand houses on what was called "Silk-stocking Row." Around the same time that he completed his home, Nelson also built a large commercial structure in Round Rock. Called the J. A. Nelson Company Building, the large commercial building still stands at 201 East Main Street. The home was not as lucky. New owners razed the grand structure in the 1950s and replaced it with two new homes.

Andrew J. Palm immigrated to the Fort Bend area with his parents, Anders and Anna Palm, in the late 1840s. Anders died shortly afterward, and Anna moved with her children to central Texas, where she purchased land from her relative S. M. Swenson, the first Swedish immigrant to Texas. Later the area where Anna settled came to be called Palm Valley. The Palm family built a modest home in 1873 on land they owned outside of Round Rock (above). In the early 1900s, Andrew and his wife, Carolina Nelson, constructed a larger home near the first. In 1977, the smaller home was moved to downtown Round Rock. The larger home, constructed around 1912, still stands at its original location on Highway 79.

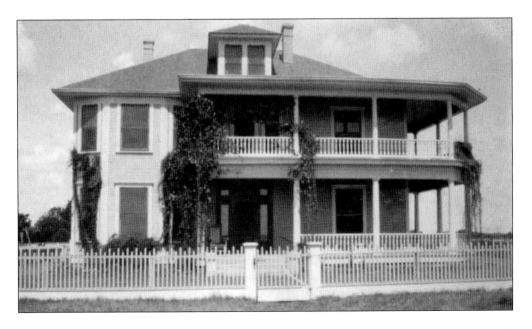

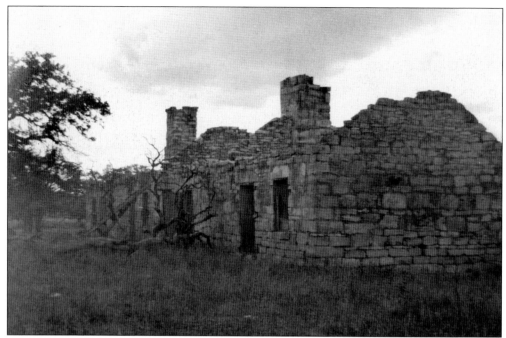

These ruins are located on land originally owned by the Williams family, who moved to Williamson County in the mid-1800s from Kentucky. Soon, the Williamses purchased land, which stayed in the family until 1956. While Williams family histories refer to the ruins as slave quarters, research of the official records show that the family owned too few slaves to need such a large building. It is more likely that the Williams family built the home for themselves and constructed simpler log dwellings for the two or three slaves they owned.

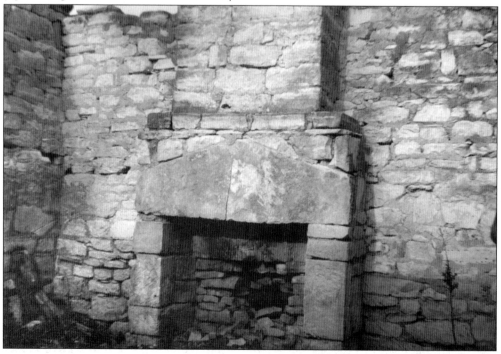

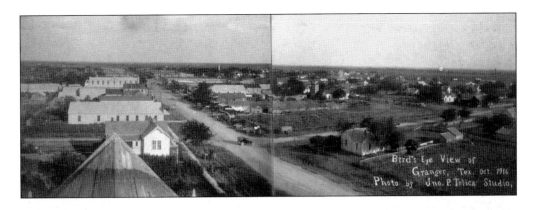

Bird's Eye View of
Granger, Tex. Oct. 1916
Photo by Jno. P. Trlica Studio.

By October 1916, when these images were taken, Granger was a bustling community. The community grew up around the Missouri, Kansas, and Texas Railroad lines that intersected at the site in the late 1880s. Soon the town became an important cotton shipping point. Large numbers of Czech immigrants settled in the area because of the cheap farmland and were a large influence, both culturally and religiously, on the town. Granger's population peaked in the mid-1920s, with over 2,000 people residing in the community. Like many rural American towns, however, its population declined as people moved to urban areas for greater employment opportunities.

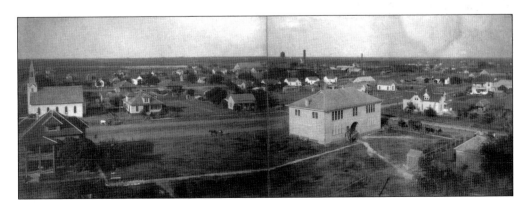

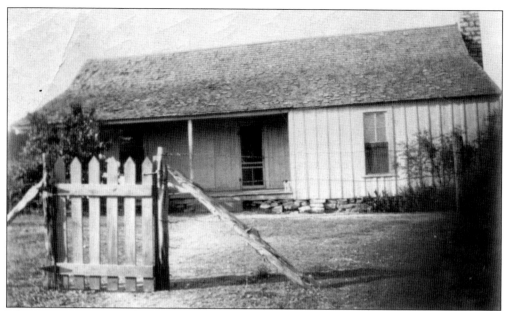

This image shows the William Fleager home located near Florence around 1880. According to the 1860 Federal Census, William Fleager and his wife, M. J., made their living as farmers and had two children, Charles and Rosell. Rosell Fleager married John Andrew Brooks Whittenberg. The Whittenbergs lived in Florence and raised all of their children in the community.

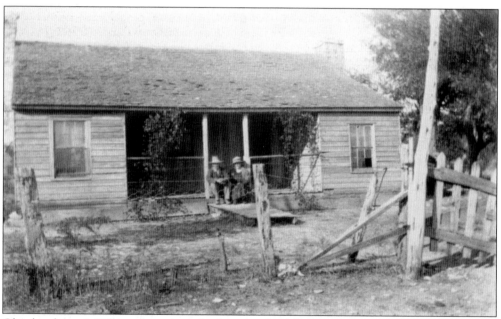

Oland and Annie Whittenberg sit on the front porch of the home of their parents, John Andrew Brooks and Roselle Fleager Whittenberg, in Florence in 1926. John Whittenberg's parents moved from Talladega, Alabama, to Williamson County in December 1852 with their 10 children and their families. John Whittenberg, a Methodist minister, died on April 14, 1898, in Florence.

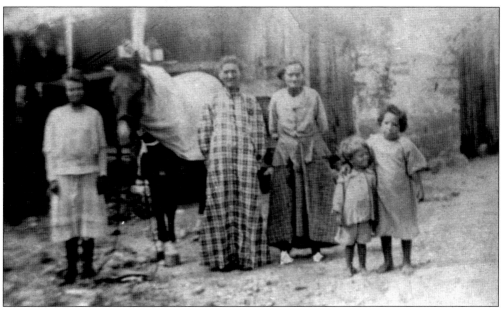

The majority of Anglo settlers moving to Texas came from Southern states, and many brought their slaves. Texas considered slavery vital to its economic and future growth. Early settlers believed that an area so land-rich and labor-poor could only be settled and brought into large-scale production quickly with slave labor. By 1855, Williamson County had 757 slaves, and at the outbreak of the Civil War, over 1,000 slaves lived here. August "Gus" Fisher, a former slave, came with his owner from Arkansas. The Fisher family (above) settled in the Andice/Florence area. The image below shows Gus and Sally Fisher's children posing in front of George Fisher's home in the early 1930s. Standing from left to right are Sam Fisher (1876–1956), Sally Fisher Arnold (1877–1970), George Fisher (1879–1949), Robert "Doll" Fisher (1882–1947), Mary Fisher William (1884–1974), Jozie Fisher (1886–1956), Elzie Fisher (1894–1974), and A. B. Fisher (1898–1980s).

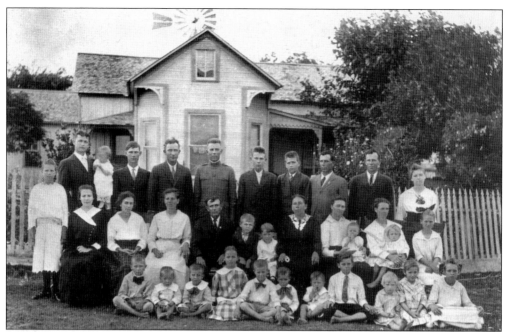

Ludwick and Julia Tobolka Cervenka and their extended family pose in front of their Queen Anne–style home in 1920. The Cervenkas immigrated to Williamson County in the 1890s, and Ludwick and Julia owned 2,000 acres of farmland west of Granger. They had 11 children, also pictured here with their spouses and children.

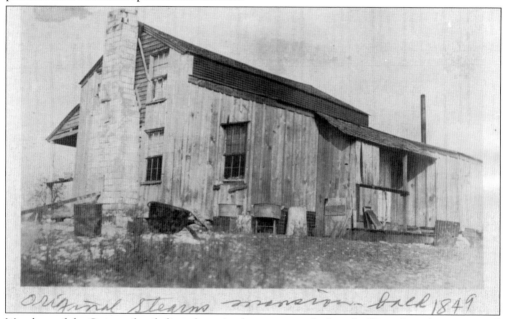

Members of the Stearns family have been in the area since before the Texas Legislature created Williamson County. Zara Stearns, who immigrated to Texas from Vermilion County, Illinois, signed the petition to create the county in 1848. This image comes from Clara Stearns Scarbrough's collection of photographs gathered for her book *Land of Good Water*. It shows the rear facade of the old Stearns mansion located between Circleville and Jonah around 1849.

From the Granger area, William and Mary Janak Cervenka stand in front of their home with their children and an important portrait, which most likely honors a departed relative. The Cervenka and Janak families were early immigrants of Czech and Moravian descent. The Janaks were the second Czech family to settle in Williamson County.

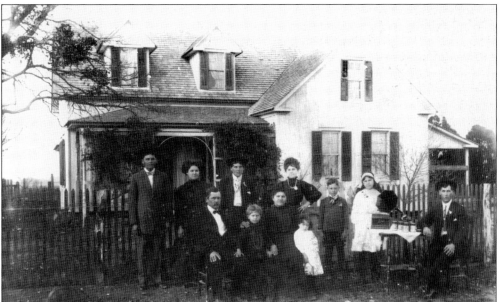

Paul and Rozina Machu immigrated to Texas from central Moravia in 1871. The family eventually settled 4 miles northeast of Circleville. Paul and Rozina's son John bought land near the family place. In this photograph, John Machu and his family celebrate the double wedding ceremony of two of his sons, Joe and John Jr., around 1910. This wedding celebration was held at home with the entire family in attendance.

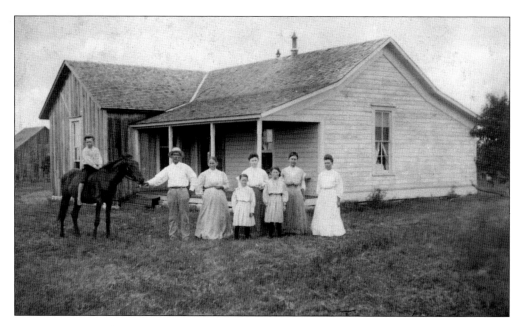

Between 1840 and 1915, over one million people left Sweden and immigrated to the United States. More than 11,000 chose to settle in central Texas. The region lured Swedish immigrants for a number of reasons: cheap land, help from family or friends already in Texas with the cost of passage, and the fact that other Swedes had already settled here. They spent time clearing the land, building barns, and planting crops. The work was not easy, and every member of the family pitched in, because success on the frontier was not ensured. As with all ethnic groups that made the decision to come to the United States, these settlers strove to survive, adapt, and succeed in their new lives.

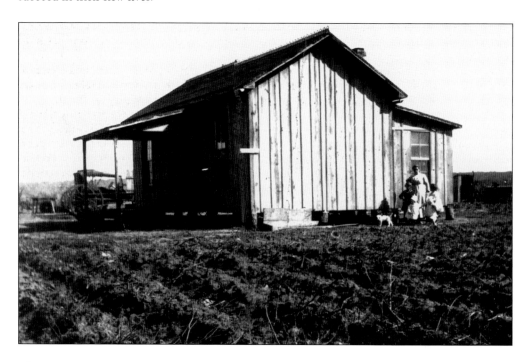

Four

AGRICULTURE

The land lured people to Texas. The terrain in much of central Texas was rich with trees, rivers, and creeks, and the soil was ideal for agriculture. Consequently, most of the county's early frontier settlers were farmers. As early as 1846, the year Texas became a state, pioneers established farms along Brushy Creek in Williamson County. These first residents—and, in some cases, their slaves—came ready to work: they bought or rented land and spent time clearing it; constructed homes, barns, and other buildings; and helped plant, care for, and harvest crops. It was not easy work, but everyone labored daily to keep the county's homes and farms running—and generally, they did.

An 1860 agricultural census noted county farmers with crops of wheat, corn, and cotton. In addition, the census reported that family farms raised cattle for both personal subsistence and profit. Over 38,000 head of cattle and almost 17,000 sheep grazed the county's pastures.

Mills and, later, gins were essential to the agricultural way of life. The county's first gristmill was established in 1843, and later they began popping up throughout the area. The early mills and cotton gins were powered by water, which required a dam to supply a steady stream of water to drive the machinery. By the early 1900s, most mills and gins had transitioned to steam power.

After the Civil War, farm and livestock values dropped significantly, but the county rebounded with a boom in cotton farming. Additionally, numerous cattle drives formed in Williamson County on the Chisholm Trail. Agriculture was the county's main economic factor in the 19th and early 20th centuries, drawing immigrants from Europe to Williamson County. The land attracted people to central Texas, and once here, they branched out into other businesses, ensuring the county's continued growth and success.

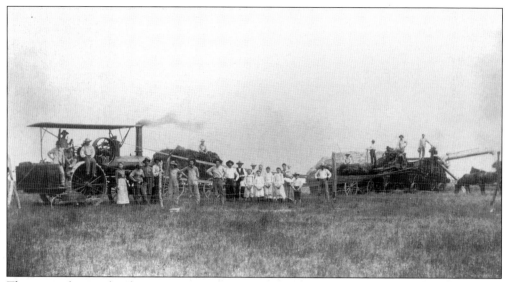

This image shows a threshing crew at the Kasperik farm, located between Walburg and Schwertner, around 1913. In many instances, harvest time was a community affair. Neighbors, men, women, and children would pitch in, working sunup to sundown and beyond, staying until the work was finished. Not all work was done on a volunteer basis: an enterprising owner of a threshing machine might travel farm to farm, working for a number of families within the area.

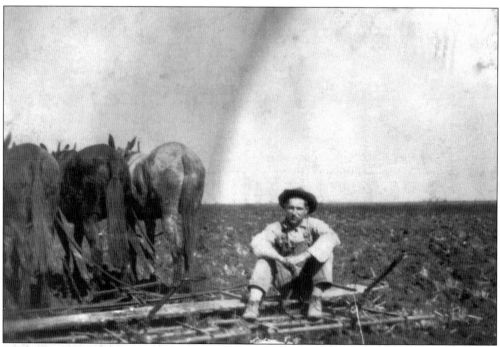

Before tractors, farmers relied heavily upon mules and horses to perform numerous jobs on the farm. Usually, mules pulled the farming equipment, and horses were used to pull buggies and work livestock. Later, as the machines became affordable, farmers began to trade in their mules and horses for tractors. Here Louis Kruger poses with three mules in a field near Norman's Crossing, located southeast of Hutto.

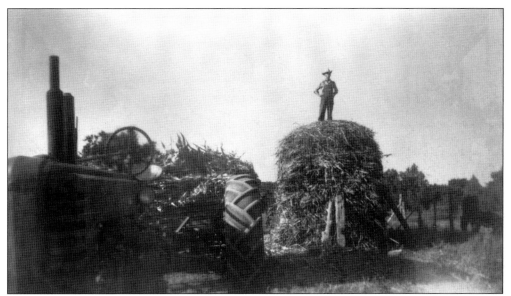

Stacking hay for winter-feeding stock is hard, dirty work. The hay is mowed, raked, and allowed to dry. It is raked a second time and stacked into a big pile. Stack hay is then forked out to cattle or other farm animals with a pitchfork. In this 1930s image, Rudolph Cmerek works on the Joe Cmerek Sr. farm 8 miles west of Granger baling, hauling, and stacking hay.

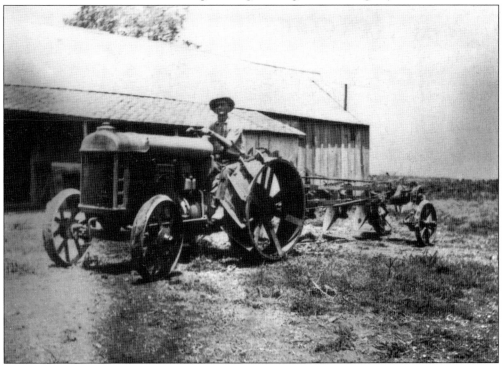

In 1920, there were only 225 tractors in the entire United States. Not many farmers could afford them. Most still used mules or horses to pull equipment that plowed, planted, or harvested crops. This image, taken in the 1920s, shows a farmer with his tractor. Notice the steel wheels; the first rubber tractor tires were not sold until the early 1930s.

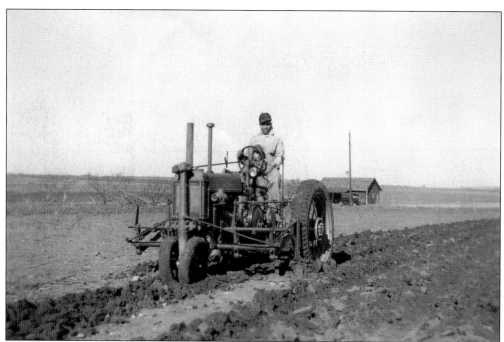

In the 1930s and 1940s, many farmers switched to the tractor. Sometimes, farmers would pool their resources to purchase one. Other times, a farmer would take the plunge alone, then rent out his tractor to work his neighbors' farms. The switch to motorized equipment allowed farmers to work more acreage than ever before. In the late 1890s, a farm crew would expend 35 to 40 hours of labor to produce 100 bushels of corn. By 1930, just 15 to 20 labor hours produced the same yield. Rain or shine, hot or cold, farm work must be done, and tractors helped make this possible. The above image shows Sigurd E. Johnson in the 1940s, plowing his farm (northeast of Jonah) on his John Deere tractor. The image below shows V. Kokel of Walburg in 1941 with his John Deere continuing to perform farming duties in the snow.

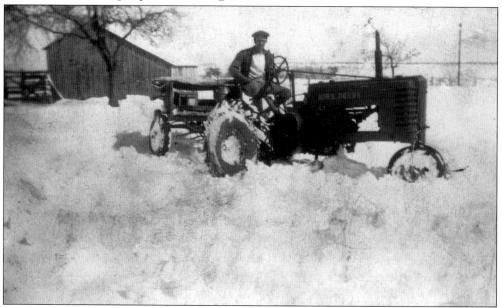

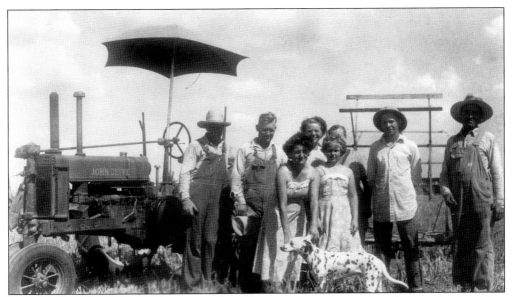

Rod and Sigurd E. Johnson (far right) pose with cousins in front of their John Deere tractor and a cane/hay binder on their farm in Jonah around 1951. Early tractors did not have enclosed seating areas like many do today; the Johnsons modified theirs for the Texas heat by adding an umbrella.

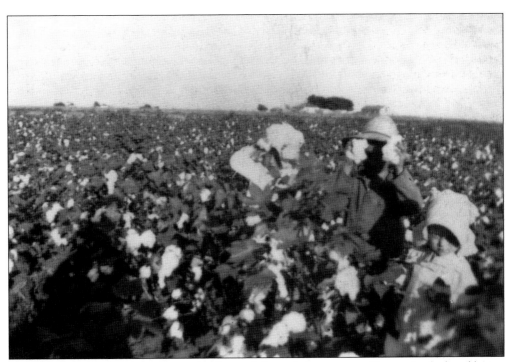

Cotton was planted in the spring and cultivated through the summer. Harvesting by hand began in August. On most farms, bringing in the harvest required the efforts of every family member, including children as young as five years old, as well as that of friends and/or paid hands. In this image, Gracie, Sunny, and Nancie Pavliska help pick cotton on a farm near Granger.

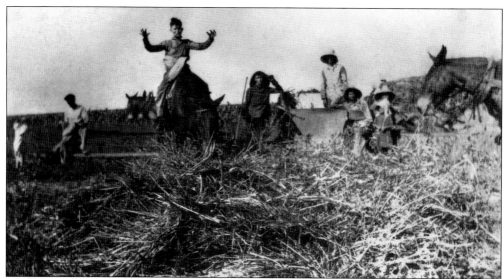

Hay is a mixture of various grasses (and sometimes oat, barley, and wheat) that is cut, dried, and stored as feed for animals, including cattle, goats, and sheep. Here workers on the Frank Cmerek farm (near Granger) bale hay around 1919.

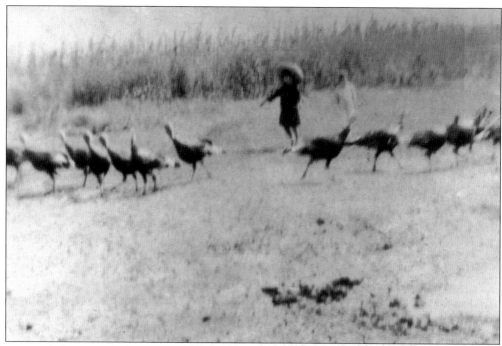

Large numbers of families in central Texas subsisted as tenant farmers, living on a landowner's property and working the land. Tenants provided about one-third of their production or earnings to the landowner to pay for use of land and buildings. Lorraine Castro and her brother Frank help round up turkeys on a tenant farm around 1924.

Many tenant farmers lived in houses on the property they rented. Tenants supplied their own farm animals, tools, and seeds for planting. From the results of their hard labors, they received up to two-thirds of the materials they produced. Nonetheless, normally after accounts were settled, tenant farmers had little or no cash left over. This image shows a tenant farm family outside their home.

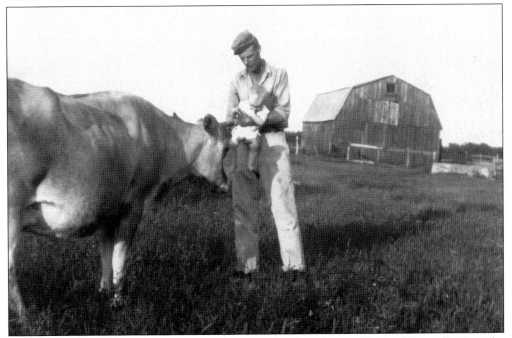

On his farm in Andice, Grady Howland holds up his daughter Connie Howland Kanetzky to see the family's Jersey cow, Pet, named for the milk company. Most farmers also raised cows to provide the family with much-needed milk, from which such things as butter and cream could be made.

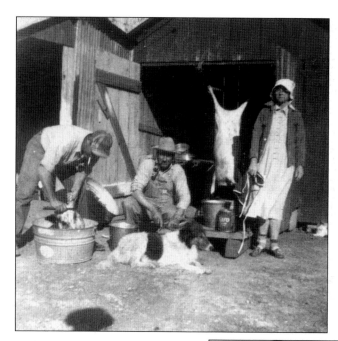

Farms grew more than just cash crops; they also had a vegetable garden, and often a fruit orchard. Farmers raised chickens, hogs, and cattle, as well as the horses and mules needed to work the fields. At left, three adults work together to butcher a hog.

The image at right shows Paul Osuna and an unidentified helper hoisting a hog onto a trailer. First, a hog was killed and then hoisted off the ground so that it could be dipped into a barrel of hot water to prepare the skin to be scraped. Next, the head was removed, which has already been done in this image. Later the hog was gutted and the carcass carved up to remove the meat. A portion of fat from the hog's gut was put into a pot over a small fire to render. As the initial fat rendered, additional fat was added slowly. After a few hours of cooking and stirring, the family had lard.

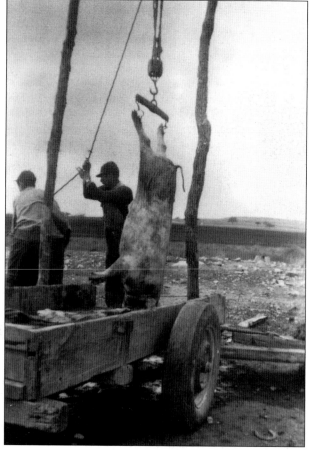

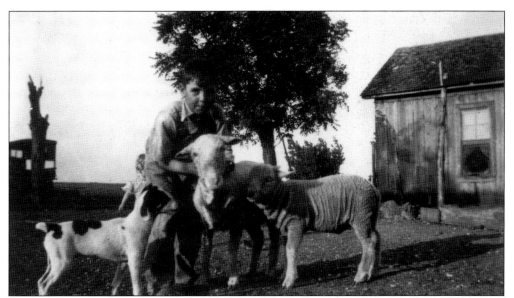

Diversification went a long way to ensure the success of farms. Many farmers planted more than one type of crop and raised more than one type of animal. Vernon Krueger and his sister Bertha, just barely visible behind Vernon to the left, stand with their sheep (ewe and lambs) on a farm located between Hutto and Taylor.

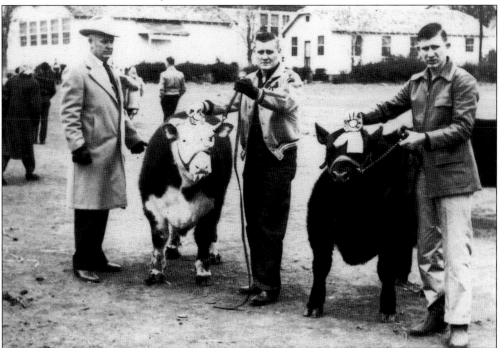

The U.S. Congress passed the Smith-Hughes Act in 1917. The act promoted vocational agriculture training to people preparing to work on a farm. In 1928, the Future Farmers of America was founded to bring students, teachers, and agribusiness together to support agricultural education, which prepares students for successful careers in agricultural professions. In this undated photograph, an agriculture teacher and two boys pose with their show cattle.

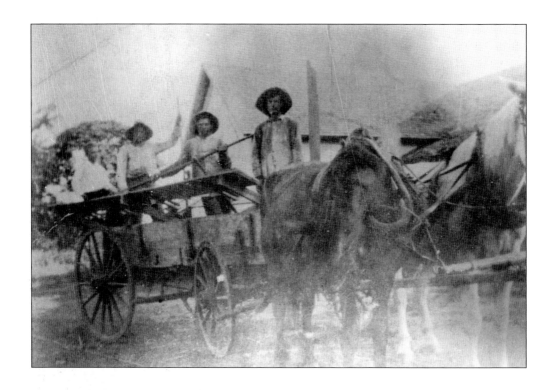

The image above was taken in 1919, where men on the Frances Rozacky farm, 4 miles south of Granger, prepare to haul hay (cane). The men are, from left to right, Robert Rozacky (seated), Joe Chasek, Adolph Horak, and Joe Rozacky (Robert's father). The cane was stacked in haystacks that measured 20 feet long by 8 to 10 feet wide and 6 to 7 feet high. In the photograph below, Sidney and Bert Johnson (on the left) work with hired hands to stack bundled cane (hay) on the family farm near Jonah in the 1950s.

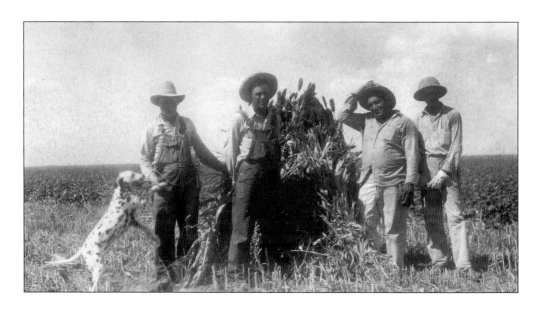

Men load a truck with an onion harvest in Thrall in the 1940s. Harvesting onions involved plowing them out of the soil, letting them dry for a few days, and removing the tops. After a few more days of drying, the onions were sacked in the field, as shown here.

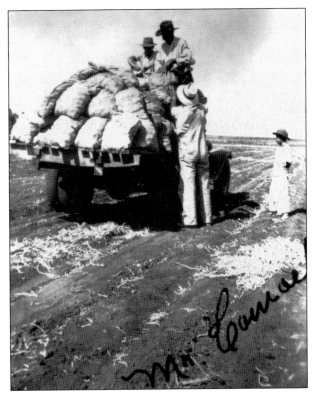

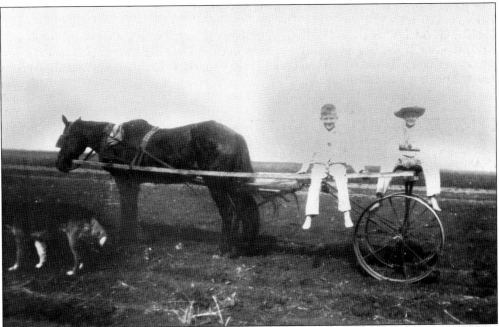

Donald and Larry Rydell help in the cotton rolling process, or "roll" cotton, on the family farm located northwest of Taylor around 1947. Rolling cotton keeps the soil around the cottonseeds from drying out after they have been planted. In general, cotton is a very thirsty crop, so ensuring that it had the necessary amount of moisture was important to its success.

After the end of slavery, many African Americans from Williamson County stayed in the area. They managed to find work to survive and to support their families even though they were barred by discrimination from a number of professions. According to census records from 1870, African Americans in the county worked as laborers, farmers (probably sharecroppers), teamsters, and wagon makers. These undated images from a family photograph album show two unidentified African Americans, a man and a young boy, working as laborers on the Palm family property, which was located on Highway 79 in Round Rock.

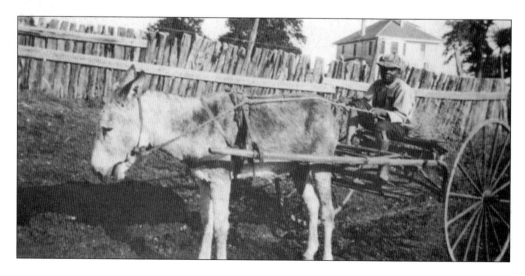

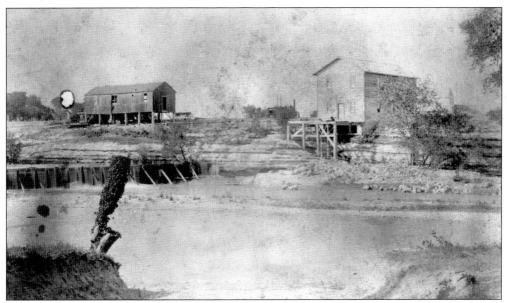

The image below shows men standing in front of the dam they helped build on the San Gabriel River to provide power to a flour mill near Jonah. According to historical accounts, a project to construct a wheat and corn mill in the area began in 1857. In a water-powered mill, water diverted from a source such as a river or stream drives the blades of a wheel, which in turn rotates an axle that moves equipment. Sometime around 1902 or 1903, fire destroyed the flour mill that was powered by the water diverted from this dam.

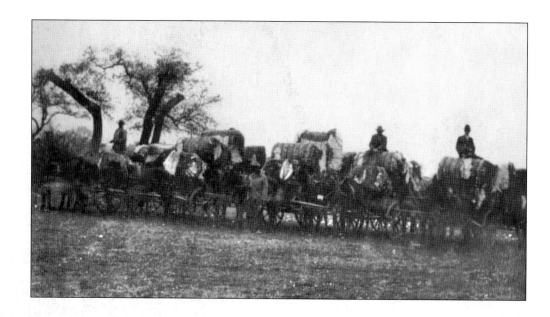

Texas placed eighth in the nation for top 10 cotton-producing states in 1852. In the 1870s, many people moved to Texas and began growing cotton on small family-owned farmsteads or on large farms as tenant farmers or sharecroppers. By 1900, Texas farmers produced 3.5 million bales of cotton from over seven million acres of cultivated land. Before county farmers had access to trucks to move cotton to railroads, the bales were stacked on wagons pulled by horses or mules. These undated images show the cotton produced from the Palm family farm in Round Rock. Today about 30 percent of the land in Williamson County is still considered prime farmland.

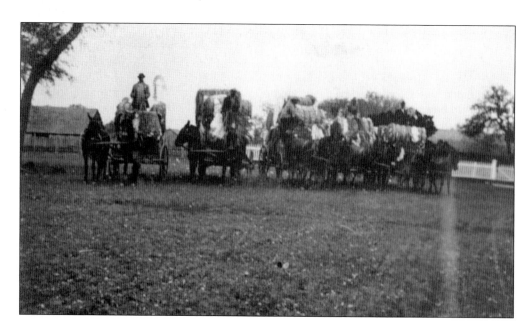

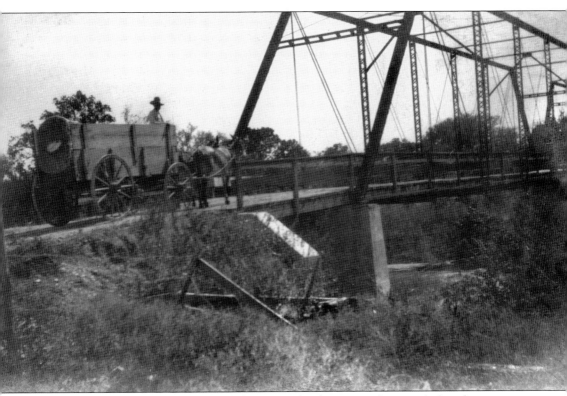

Infrastructure, such as roads and bridges, helps ensure that farming products reach their destinations. Here a farmer drives his mule-drawn cotton wagon over a bridge near Jonah. While most residents of Jonah celebrated the 1904 opening of the bridge, some did not. The *Williamson County Sun* newspaper printed the following around 1910: "The Jonah people want to know if there is not some way to prevent fast riding and driving across the new bridge. Men run their horses on it, and loaded wagons are driven in a trot across it. Unless the practice is stopped, the bridge will soon be destroyed for travel." The excessive spirits of those earlier travelers had nothing to do with the downfall of the bridge, however; a massive 1921 flood washed the bridge away.

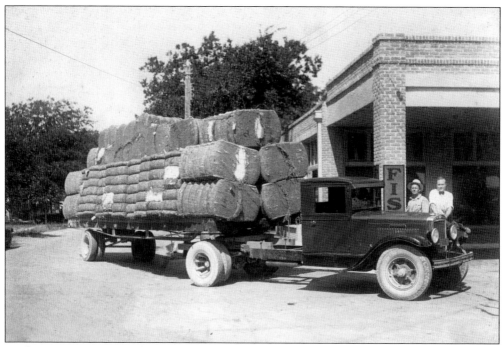

By the 1920s, Texas cotton production began to decline. Factors contributing to this included a federal program that cut acreage in half, an increase in foreign production, and the lack of a lint-processing industry in the state. Cotton production moved to larger operations that used fewer laborers and more machinery. Farmers moved cotton bales from gins to the markets or railroads using trucks by the late 1920s. In the image above, Albert William Lindell (right) stands next to a truck loaded down with cotton bales. The other image shows a truck hauling cotton bales to market, parked in front of the Miller Motor Company.

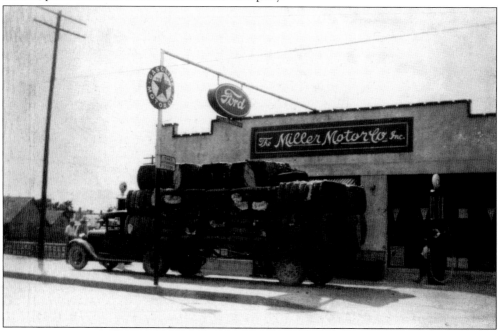

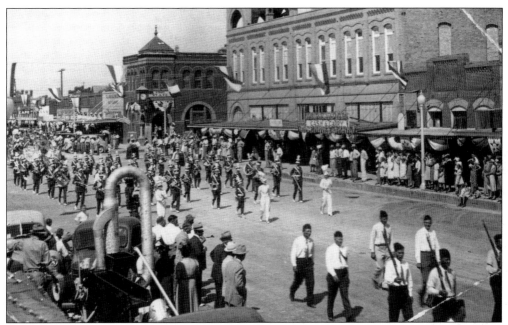

After too much cotton production had drained the soil of its nutrients, farmers turned to corn. Williamson County became the top corn-producing county in Texas by the late 1930s. In 1938, leaders of the state Grange, the East Texas Chamber of Commerce, and Texas A&M University agencies combined forces to hold a Corn Carnival in September of that year. The festival included a parade through downtown Granger (above) that drew almost 20,000 people. The image below is a promotional photograph for the carnival. Pictured are (kneeling, in no particular order) Albert ?, Rudolph Wrba, Jerry Martinets, and unidentified; (standing, from left to right) L. C. Salm, Louis Zelenovitz, J. D. Roberts, Mayor Frank Martinets, Ralph Moore, Adolf Naizer, John Baca, Edward Kerbala, and C. W. Williams. Festivities included a corn-pulling contest held on the Naizer farm, a mile northeast of Granger.

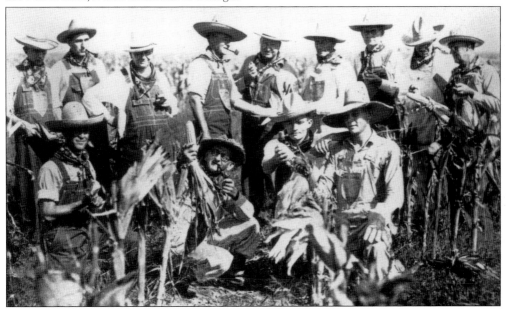

PATRONS OF HUSBANDRY.

State of Texas. _Williamson_ County.

Secretary's Quarterly Report to State Treasurer.

Secretary's Quarterly Report of _San Gabriel_

Grange No. _611_ for the Quarter ending _June 80_ 188 _5_

CONSTITUTION: ARTICLE XI. The Secretary shall keep an accurate record of all proceedings of the Grange, proper to be written, make out all necessary returns to the National Grange, keep the account of the Subordinate Granges with the State Grange, and pay over every ten days to the Treasurer all moneys coming into his hands, and take a receipt for the same. He shall keep a complete register of the number and name of each Subordinate Grange, a tabular statement of the quarterly returns and dues of the Subordinate Granges.

Number of Members.		Gained.			Amt. Sent Sec. State Grange Last Report.	Amount Sent at this date.	REMARKS.
Last Report.	This Report.	Initiation.	Card.	Loss.			
39	39				3 12	3 12	

Master.

P. O. Address,

W. S. Rude _Secretary._

P. O. Address,

Nearest Express Office,

The Secretary should make out ten reports, and file duplicate in his office.

The National Grange, also known as the Order of the Patrons of Husbandry, is the oldest surviving agricultural organization in the United States. The founders created the National Grange to provide service on such issues as economic development, education, and legislation. Citizens united to improve the social and economic position of farmers by establishing organizations in all regions of the country. The state and local organizations created buying cooperatives, as well as cooperatives for grain elevators and mills. In 1873, Texas farmers organized the state's first Order of the Patrons of Husbandry. By 1876, the Texas Grange had 40,000 members in 1,275 lodges, including an active membership in Williamson County. The image above shows farmers in the Granger area. Some sources suggest that Granger was named after its local Grange lodge. By the 1880s, several Grange cooperatives opened in Williamson County to buy and sell farmers' produce. The document at left is a quarterly report of San Gabriel Grange No. 611 to the state treasurer for June 1885.

The Schwertner family emigrated from Austria in 1877. The family arrived in Texas by way of Galveston and initially settled in Rice's Crossing. The next year they moved to Corn Hill. The image above shows Frank Schwertner's cotton gin around 1902. A year later, Adolph Schwertner bought this gin from his brother. In 1909, the Bartlett Western Railway constructed a line near the gin, and by 1910, the community that had grown up around the gin was known as Schwertner. Adolph agreed to donate land and lay out an official town site in 1911. Adolph Schwertner strove to ensure the success of his community, helping to organize the First National Bank and encouraging business growth throughout his lifetime. A general store, blacksmith shops, a post office, and a small school all supported the community, shown below about 1900.

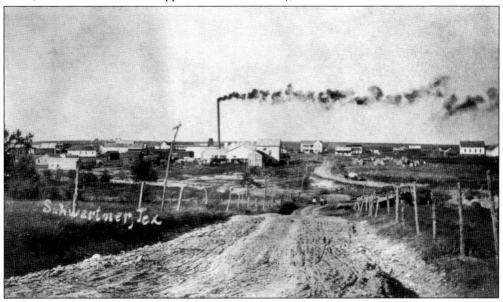

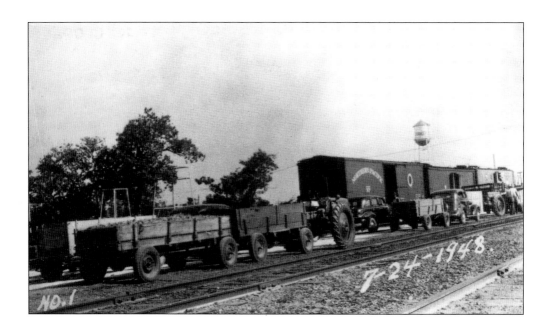

Far more than a food source, corn is a very versatile plant. In the 19th and early 20th century, the cobs were used as stoppers in jugs and bottles, as handles for tools, and as firewood. Husks were used as wrappers, writing paper, and as mattress and pillow stuffing. In the days before the Texas Revolution, corn was even used as an exchange medium: settlers paid Stephen F. Austin 10 to 20 bushels of grain annually to cover the expenses of his colony's deputy to the Mexican Congress. During the Civil War, the Confederate government asked farmers to plant more corn and less cotton because they needed a steady food supply. By the 1930s and 1940s, Williamson County, along with only two other counties, led the state in corn production. These images, taken on July 24, 1948, show corn being loaded onto a train.

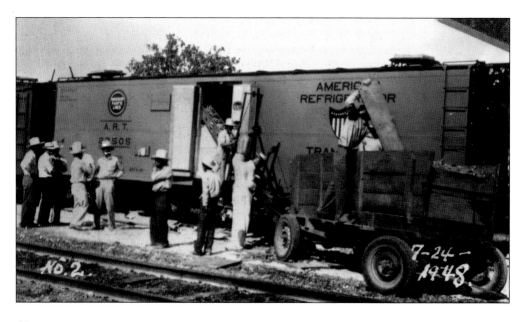

Five

EDUCATION

In 1854, six years after the county's establishment, the Williamson County Court organized 14 school districts. That year, the Texas school census reported 65,463 students in the state. At that time, the state fund appointed 62¢ for each student. These early rural schools were usually wooden buildings that also served as places of worship on Sundays and as venues for community events at night. Classes at rural schools came to a halt during the planting and harvesting seasons, or if winter weather was too inhospitable for students to make the trip to the classroom. In the winter, wood-burning stoves heated schoolhouses, and in warmer weather, teachers often conducted classes outdoors.

Funding for early schools was limited, classrooms were small, and in many cases students of varying age levels attended class in the same room, sharing desks and textbooks. Nonetheless, Williamson County boasted high-quality educators, and despite the obstacles, they provided county students with an exceptional educational experience.

Texas passed a rural high school consolidation law in 1911, establishing boards of education for each county. The law also caused many smaller, rural schools to close or incorporate into the larger schools with more funding. Today Williamson County is home to more than 90,000 students consolidated into 11 public school districts.

Zion Lutheran School in Walburg, St. Mary's Catholic School in Taylor, and SS. Cyril and Methodius School in Granger are examples of early private institutions established in Williamson County. They are a testament to the importance that settlers, who used their own time, money, and resources to open the institutions, placed on education.

Williamson County has a rich history of higher education as well. Southwestern University, chartered in 1875, was one of the first private universities in the state. Round Rock established Greenwood Masonic Institute in 1867, later becoming Round Rock College in the 1880s, and Evangelical Trinity College, which opened in 1906. Smaller communities, including Florence, Corn Hill, and Liberty Hill, established colleges in the late 1800s. These colleges were opened using public and private funding, had boards of directors, and were chartered by the state. This tradition of education continues today with Southwestern University, Round Rock Higher Education Center, and Temple College in Taylor.

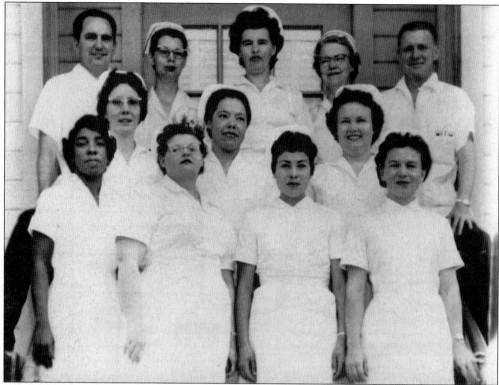

The photograph above shows the first graduating class of the Georgetown School of Vocational Nursing in 1961. From left to right are (first row) Alice Henry, Opal Shelton, Ramona Guerrera Jasso, and Evelyn Shell; (second row) Nettie Dixon, Dorothy Fisher, and Nancy Gibbs Lambert; (third row) Douglas M. Benold, M.D.; Joyce Jackson, R.N.; Pearl Homeyer; Golden Munson, R.N.; and Hal Gaddy, M.D. The image below shows the 1963 graduation class of the Georgetown School of Vocational Nursing. The doctors from left to right are Douglas Benold, James Shepard, and Hal Gaddy. The graduates include, from left to right, Sipirina Richarte, Katherine Kelley, and Jovita Richarte.

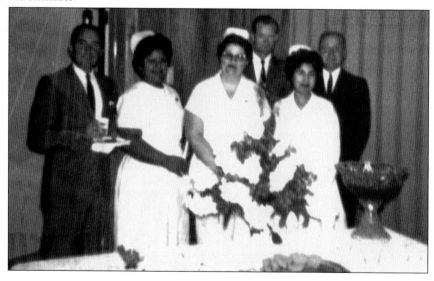

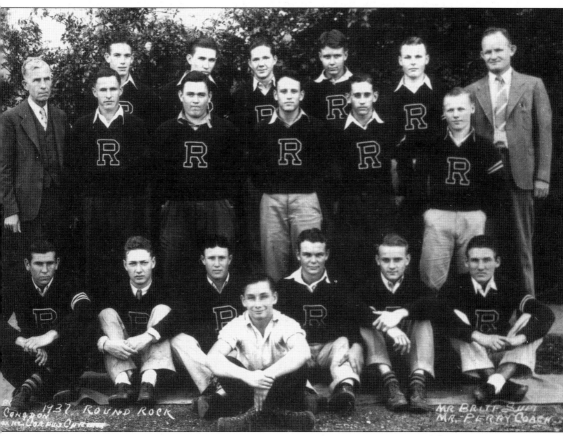

This is an image of the 1937 Round Rock Dragon football team with coach O. F. Perry (back right) and Superintendent Britt (back left). The team mascot, S. A. Womble, is seated front center. University Interscholastic League (UIL) conferences were labeled "A", "B" and "C" at the time, in relation to a school's size, with "C" representing the smallest schools. The Dragons were the District 7C champions in 1937, going 3-0 in district and 7-2-1 for the season. Playing against Manor, the 1937 team blocked three punts in one game—still a school record today. The 1937 season brought the first night game to Dragon Stadium—a disappointing 13-0 loss to Elgin. The Round Rock Booster Club raised the funding for the lights.

The Round Rock High School Pep Squad, shown in the image above, supported Round Rock athletes at home and on the road. The group later became the Round Rock Dragonettes, serving a similar function as the original pep squad. In the 1930s, Arvilla McVey was the pep squad sponsor. The cheerleaders shown in the foreground of this image from left to right are Marjorie Johnson, Artie Louise Ferrell, and Matilda Brady. The origin of the name "Dragons" for Round Rock athletic teams resulted from a contest held by students, and it was formally adopted in 1926. The image below shows the Round Rock Dragon football team in 1946 with coach O. V. McDaniel. This team was District 32B champions with 5-0 district and 10-2 season records, capping seven straight seasons as solo or cochampions. The only two losses that year came from Georgetown and Luling, both larger, class A teams.

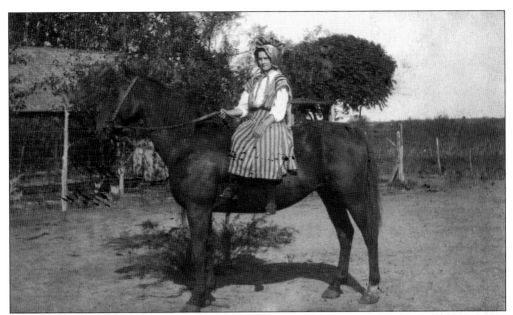

Early rural Williamson County residents did not have the luxury of school busses to transport them to the classroom. The local schoolhouse was often many miles away, and the only way students could reach the classroom was by foot, horseback, or by horse-drawn carriage. The image above shows a young girl from the Granger area seated on the back of her trusty mode of school transportation: her horse. Below, a group of Leander teachers in 1922 prepare for an outing with their beaus in a mule-drawn carriage. In good humor, the group has attached a license plate to the harness of the mule.

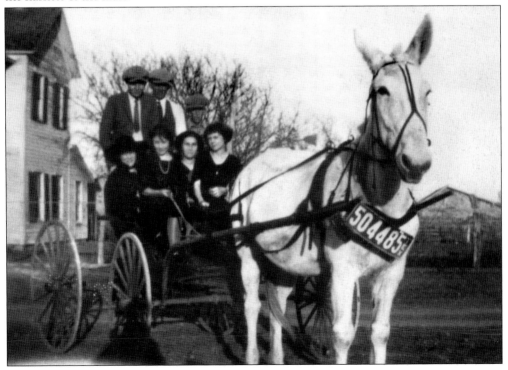

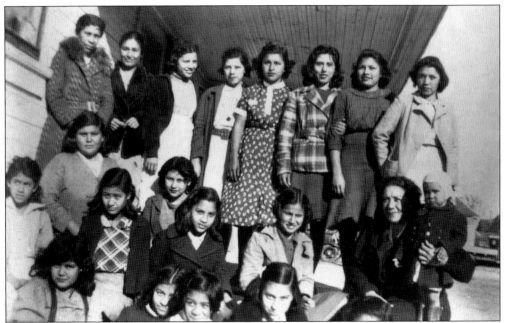

The Alamo School, originally located at 702 Sturgis Street in Taylor, was a segregated school for Mexican American students. The photograph above shows a group of Alamo School pupils and their parents around 1939. This school was known alternately as the Alamo School, Mexican Ward, and South Side Elementary. The earlier class photograph (below) from the same school in the 1920s shows the entire student body. Mexican American students in Williamson County were integrated into Anglo schools much earlier than the county's African American children. Mexican students integrated into the Georgetown Grammar School in the 1947–1948 school year, but black students did not integrate into Georgetown schools until almost two decades later, with the passage of the Civil Rights Act of 1964.

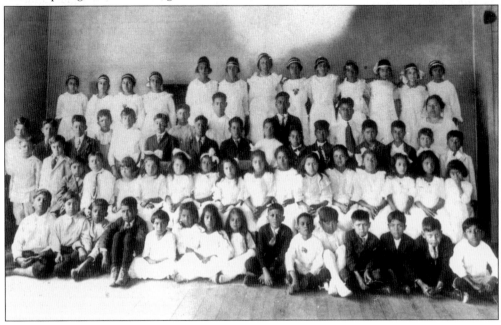

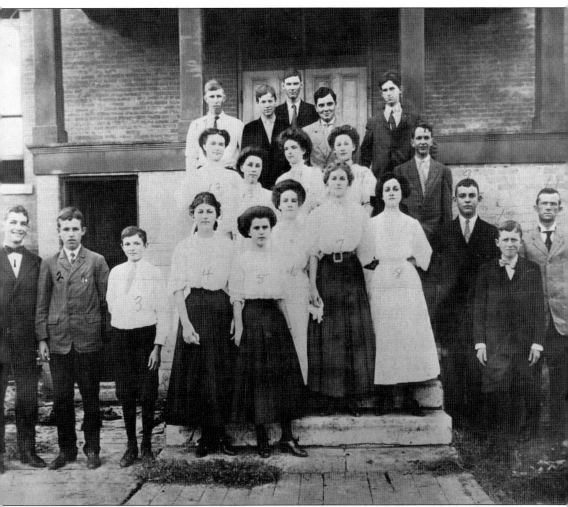

The 1909 graduating class of Taylor High School, shown above, included future Texas governor Dan Moody (standing front right). The Moody family resided at 400 Porter Street in Taylor. The family's beautifully preserved home is now the site of the Moody Museum.

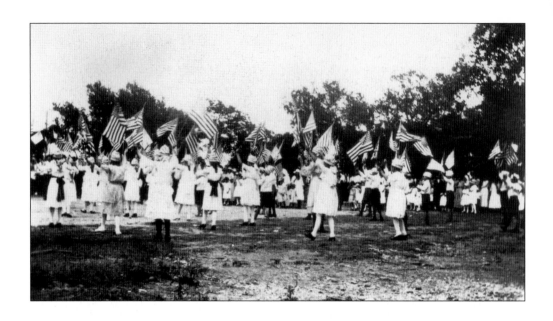

The private Zion Lutheran Church and School was originally established for immigrants of German-Wendish descent. The school opened in Walburg in the 1880s. The school and church have served as a community gathering place for over 125 years, hosting many large events including the Wurstbraten Sausage Supper, an annual event since 1971. The image above shows Zion students performing a flag drill for the annual school picnic around 1920. Below, teachers D. H. Kieschniek and K. J. Wrater pose with Zion's class of 1930.

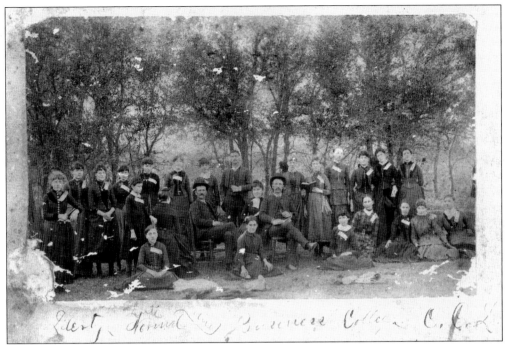

Liberty Normal and Business College, C. Rock

Shortly after the Austin and Northwestern Railroad reached Liberty Hill, residents successfully petitioned the state legislature to charter the Liberty Normal and Business College (LN&BC) in 1884. The grand opening of the school took place a year later, in January 1885. LN&BC students and faculty gathered for the photograph above in the mid-1890s. The first board of directors of the school included John Hudson, J. W. Potts, John Munro, J. D. Russell, and F. M. Barton. E. M. Coleman served as the first president. Upon opening, the school offered seven courses to its students. In 1887, it graduated its first class, with seven students receiving degrees. The building burned in 1903 and was replaced by a brick structure with a similar floor plan. The college moved to the community of Driftwood after the 1910 commencement.

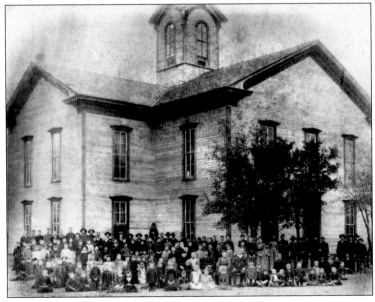

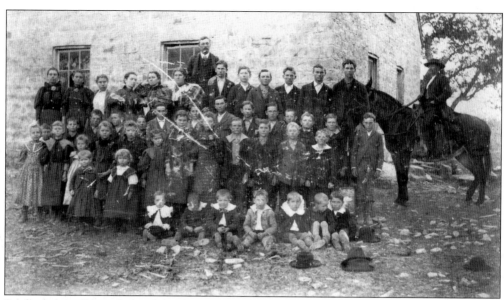

Students from Silent Grove School, west of Liberty Hill, pose for the camera around 1890. The original settlement of Silent Grove consisted of a pioneer church and school built near the home of Rev. W. O. Spencer, who began holding church services in his home in 1854. In 1870–1871, the church's congregation completed the large stone school and church building (seen here) with almost all donated labor.

```
            Commencement Exercises

             Jarrell High School
                *********

Friday Evening, May 24th, I946, 8;I5 p.m
             *****************

Processional--" Grand March" --- Verdi
              Mrs. B. C. Smith

Invocation-----------Rev. Bert Gillis

Salutatory Address----" Our Today"
              Dorothy Murray

Valedictory Address--"Lamps of the Past"
              Dorothy Kalmbach

Class Song--"The Bells of Saint Mary's"

Address------------- Dr. O. A. Ulrich

Presentation of Diplomas- Supt.M.J.Williams

Benediction----------- H. L. Jones
              ****************
```

The program at left is from the 1946 Jarrell High School graduation commencement exercises. Dr. O. A. Ulrich, dean of Southwestern University in Georgetown, gave the commencement address at the event. The original two-story redbrick school building was constructed in Jarrell in 1916 and has been in continuous use since opening. The building has been remodeled and expanded throughout the years and currently serves as one of the focal points of the community.

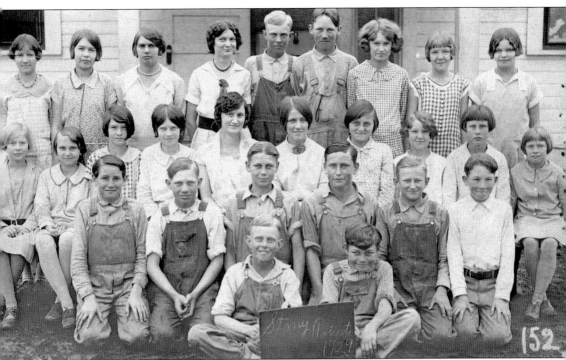

A school located south of present-day State Highway 29 served the community of Jonah as early as the 1850s. To accommodate a growing student population, school trustees purchased a lot for a second school site on Milam Branch, north of the former school, and constructed the three-room building shown above, referred to as Stony Point school. Increasing student enrollment and catastrophic flooding in the 1920s resulted in the need for a larger and safer school. C. G. Holmstrom, C. M. Gattis, and W. H. Percy led the charge, and by the 1922–1923 school year, students had a new brick school. Architect Hugo Franz Kuehne, founder of the University of Texas School of Architecture, designed the new structure. Jonah School was consolidated with schools in Granger, Georgetown, Hutto, and Taylor in the 1970s. The school building is still in use today as a community center.

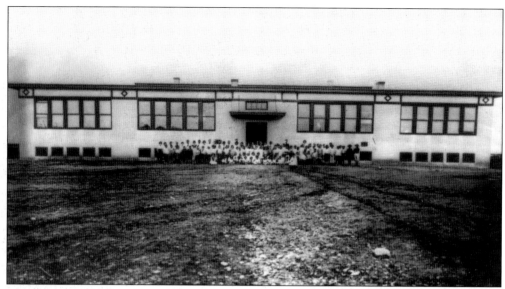

Thrall has a history of education beginning with the Stiles School, which opened in the 1880s when the community was still known as Stiles Switch. In 1903, the Stiles School was the second largest school in the county, with 215 students. The school moved to a new building in 1908 (shown above) and was renamed Thrall School. Today the Thrall School District includes the communities of Beaukiss, Hare, Noack, Sandoval, Structure, and Thrall.

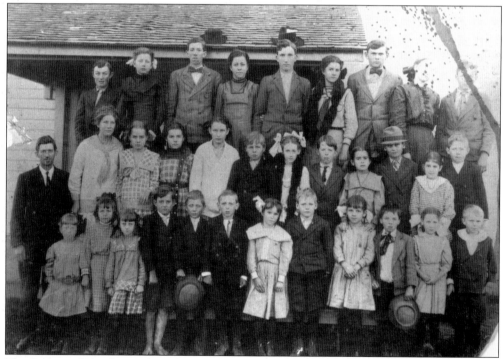

The Seymour School served residents of the Andice area until the consolidation of the Andice public schools in 1924. The school building still stands and is currently in use as the Andice Community Center. This photograph shows the Seymour School building and class in 1910. Charlie Stapp, the schoolteacher, stands at far left in the second row.

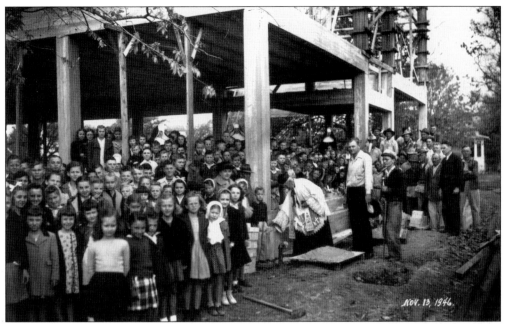

The SS. Cyril and Methodius School was established in Granger in 1899. The first school structure was a small wood-frame building. Classes for the school were originally conducted in the Czechoslovakian language. This photograph captures the blessing of the current building's newly laid cornerstone as it is blessed by a church priest on November 13, 1946.

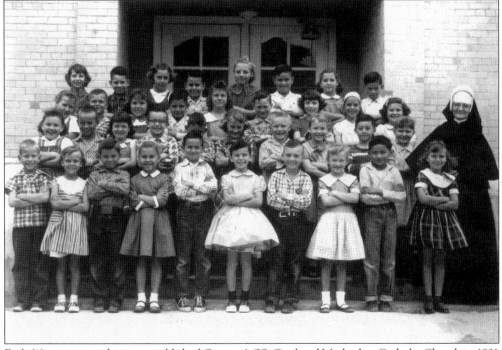

Early Moravian parishioners established Granger's SS. Cyril and Methodius Catholic Church in 1891 and opened the church school just eight years later. The Sisters of Divine Providence have provided the school with teachers since 1901. Shown above is a class photograph from the 1950s.

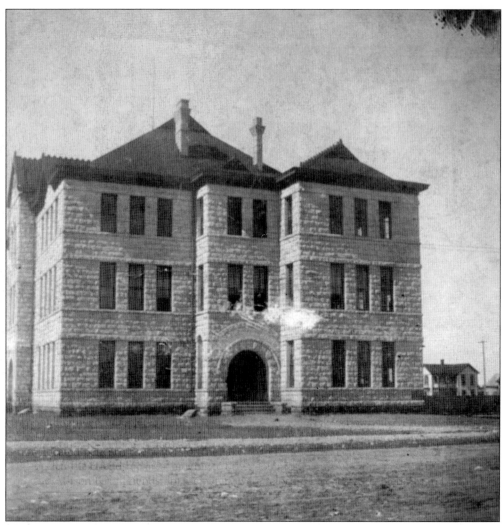

The old Georgetown Grammar School, shown above, was a three-story stone building originally located at the corner of University Avenue and Main Street where the Dos Salsas Restaurant in Georgetown now stands. The school was later renamed Annie Purl Elementary School in 1948 after longtime Georgetown educator Annie Lee Purl, who taught classes and served as the school's supervising principal from 1901 until 1950. The classrooms for the younger students were located on the bottom floor; the second and third floors housed older students as well as a library and an auditorium, frequently used for class plays, programs, lectures, and events. The Annie Purl School did not have a cafeteria until 1949, so students had the choice of bringing their own lunch to school or (with written parental permission) eating downtown or walking home for a hot meal.

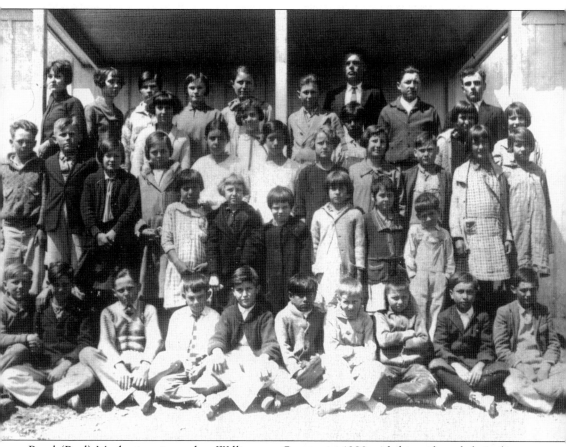

Pavel (Paul) Machu immigrated to Williamson County in 1880 with his wife and their three children. Four years later, in 1884, Machu donated a portion of his farm for a school to replace the older Dykes School, which stood 1 mile south of the new site. The school was named after Machu's native home of Vsetin Valley, located in Moravia, a historical region of the Czech Republic. This image shows a Moravia School class from about 1927 with teachers Mr. and Mrs. Cockrell. The photograph was taken shortly after trustees enlarged the original one-room school building to two rooms to accommodate additional students. The newly added space enabled the school to serve Granger-area children through the eighth grade. After completing coursework at Moravia School, students could attend high school in nearby Granger. The Moravia School closed in 1945, and its students merged with the Granger Independent School District in 1949. The old schoolhouse was moved to the site of the Crispus Attucks High School, a school that served area African Americans until Granger's schools were desegregated in 1964.

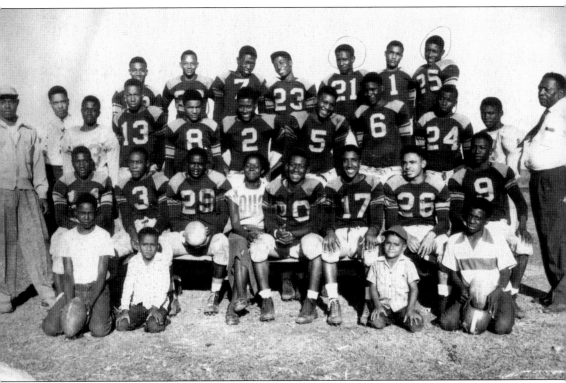

This photograph shows the Carver High School football team around 1960, six years before the integration of Georgetown's public schools. Carver High School, originally called the Georgetown Colored School, was a segregated school. The Georgetown Independent School District Board initially rejected a petition filed by concerned citizens to integrate its public schools. As a result, a group of Southwestern University students and faculty and Georgetown residents met on May 4, 1962, to discuss strategies for opposing segregation. This group became the Committee for Better Schools, dedicated to advocating equal educational opportunities for all students. Twelve black students enrolled in the first and second grades of the previously segregated Georgetown Elementary School in 1964, the first integration of Georgetown public school classrooms. The integration process was slow, but in the spring of 1966, the school board voted to fully integrate Georgetown schools, and this decision was carried out beginning with the 1966–1967 school year.

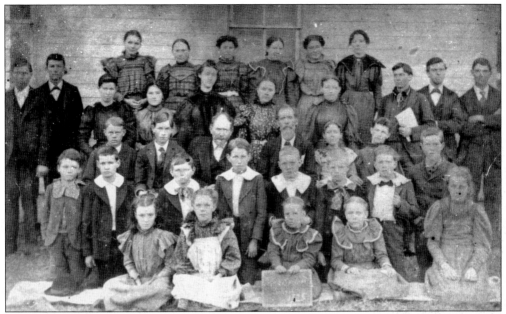

The photograph above shows students and teachers posing for a class portrait at Pond Springs School in 1896. Pioneering Williamson County settler James O. Rice settled the area in the 1850s near a spring-fed pond, the community's namesake. The Pond Springs community established a school as early as 1854 and boasted a blacksmith shop, post office, and store. The area declined after the Austin and Northwestern Railroad bypassed it in 1882. The school consolidated with nearby Jollyville in 1903 and was later incorporated into the Round Rock Independent School District in 1969. The image below shows the Pond Springs School class of 1910.

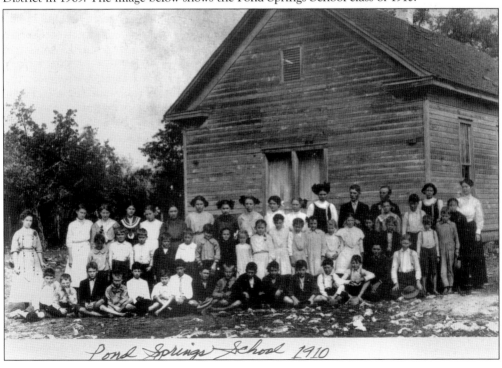

Pond Springs School 1910

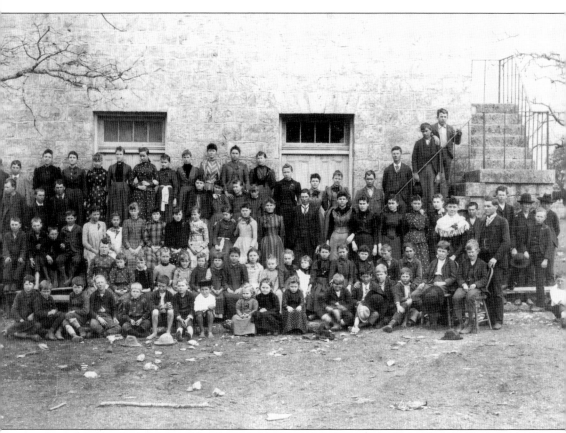

Leander school students and faculty are shown in the above image from about 1900. The stone structure in this photograph burned in 1939. The area now known as Leander has a rich educational history dating back to 1855, when the community was still known as Bagdad. Leander opened a free public school in 1893, and area leaders came together to organize a high school association in 1899. The fledgling Leander High School saw its first graduate in 1931. From these humble roots, the Leander Independent School District has grown to become the largest in Williamson County.

Six

CHURCHES AND RELIGION

Organized churches have long served as the center of many Texans' spiritual and social lives, dating back to the days before the Spanish arrived, when the religious beliefs of the area's Tonkawas, Lipan Apaches, Comanches, and other native peoples shaped tribal life. Christianity—in the form of Roman Catholicism—first appeared with Spain's conquest of the region. The Roman Catholic Church dominated the religious landscape under Spanish rule, and during the Mexican Era (1821–1836), membership in the church was mandatory for any immigrant wishing to settle in the area. After the Texas Revolution, however, American Protestants flooded central Texas and built their own churches. Later European immigrants added diversity to the civic religion by carrying over their own religious traditions and beliefs from the Old World.

The spiritual worldviews of Williamson County residents affected more than just Sundays—they were integrated into nearly every aspect of community life. They were reflected in blue laws designed to encourage Sabbath-keeping and in the popularity of Temperance and Prohibition societies in the 19th and early 20th centuries. Religious denominations have founded some of the county's most-established schools (including Zion Lutheran and SS. Cyril and Methodius Catholic), colleges (Trinity College and Southwestern University), hospitals, and many other charitable organizations.

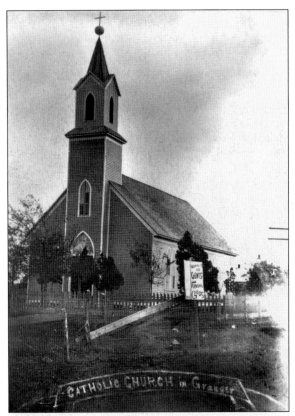

When Czech and Moravian settlers arrived in Granger in the 1880s, Catholic worshippers either traveled 12 miles to Taylor or held services in a private home. In 1891, the growing parish established the SS. Cyril and Methodius Catholic Church. The wood-frame building was constructed on land donated by W. H. Walton of Austin and named after Czech patron saints. The church grew to include a school and a parish hall, built in 1912. In 1916, under the leadership of Rev. Frantisek Pridal, the parish replaced this early building with a brick-clad church, which cost $32,000 to complete. The left image shows the earlier wooden church building; the image below shows the interior of the new church around 1920.

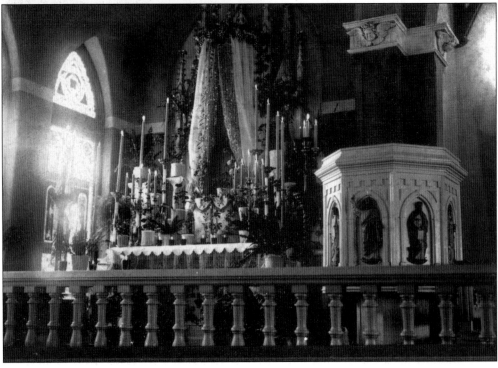

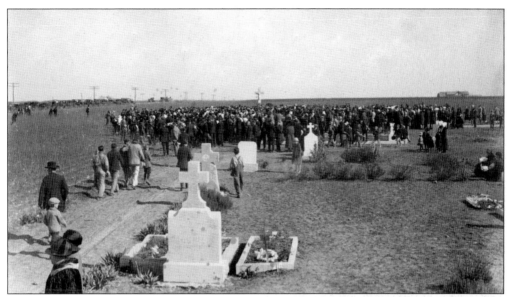

Rev. Frantisek Pridal served SS. Cyril and Methodius Catholic Church for many years. He oversaw the expansion of the physical church to include a school and parish building in 1912. He also saw the church through the construction of their second building in 1916. When Father Pridal passed away in 1927, the parish held an elaborate funeral in his honor.

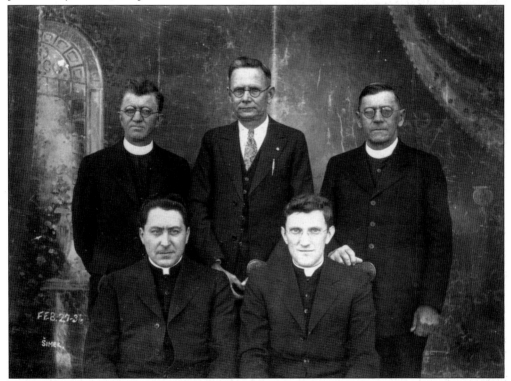

After Father Pridal's death in 1927, Rev. John Vanicek served as pastor to Granger's Catholic church. In this undated photograph of SS. Cyril and Methodius's church leaders are, from left to right, two unidentified men; (second row) Rev. Ignac Valenta, John Baca, and Rev. John Vanicek.

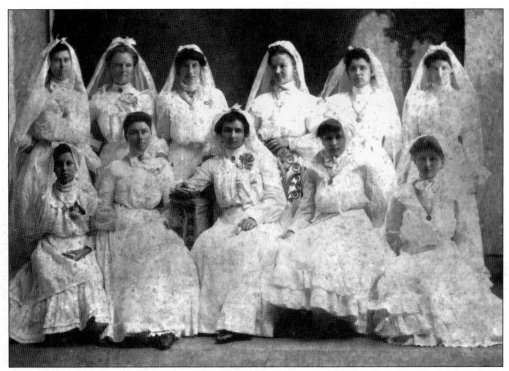

The Czech Girls' Society, shown here around 1902, took care of SS. Cyril and Methodius Catholic Church. Seated from left to right are (first row) Marie Cervenka, Mary Janak, Marcella Bartosh, Rosie Prikryl, and Bertha Prikryl; (second row) Antonie Mareck, Anna Martinka, Emlie David, Terezie Martinka, Elizabet Strmiska, and Alzbeth Nemec.

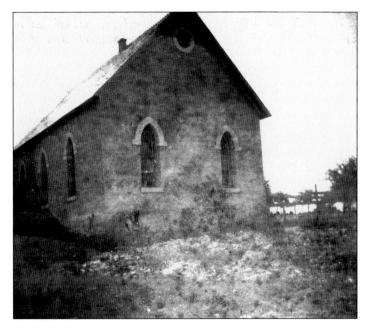

This undated photograph shows the original community center, lodge hall, and church for the community of Florence. Originally two stories tall, this stone structure was built around 1855. J. W. Atkinson and Dr. O. Benedict financed the project on land donated by John C. Caskey. In the early days, the building housed separate Baptist and Methodist congregations, along with the Masons, Odd Fellows, and a school. By 1950, an extensive remodeling project had reduced the building to one story.

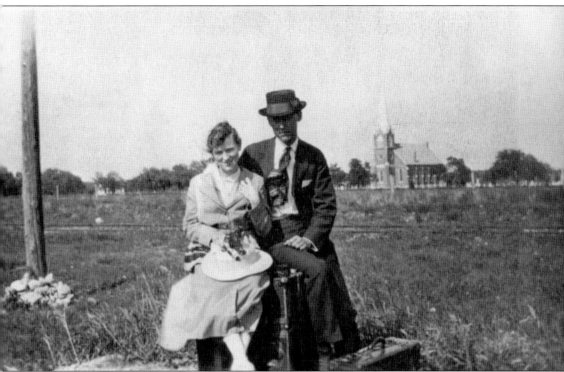

In this image from a Palm family photo album, an unidentified couple pose in front of Palm Valley Lutheran Church. Originally meeting in a simple log cabin, Palm Valley's first church, the Swedish Evangelical Lutheran Brushy Congregation, was established in 1870. Two years later, under the direction of Rev. O. O. Estrem, congregants erected a new building in which to hold religious services. By 1876, the church also hosted a school. The cornerstone for the current church structure was laid in 1894. Built by the Belford Lumber Company of Georgetown, the new church (visible in the background) cost $10,000 and was fully paid upon the structure's completion in 1896. The church was dedicated as Brushy Lutheran Church and faithfully served its parishioners under that name until 1936, when the congregation voted to incorporate under the name Palm Valley Lutheran Church.

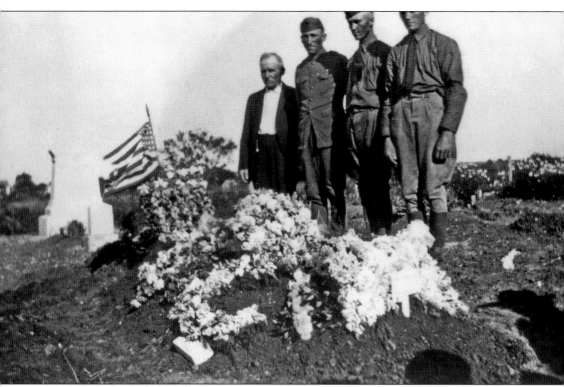

Palm Valley Lutheran Church Cemetery began in 1863 with the death of Anna Palm's youngest son, Henning. When asked where she wanted her son buried, Anna identified a spot under an oak tree. Later she wrote her nephew S. M. Swenson and asked that he donate the land where Henning was buried for a cemetery. She also asked that he provide land for a church and a school. Swenson gave the land for what would become Palm Valley Lutheran Church and Cemetery. This photograph shows the grave site of Pvt. Oscar Noren at Palm Valley Lutheran Cemetery. Noren, a soldier in World War I, died in combat on September 26, 1918, in the Argonne Forest of France. From left to right stand Noren's father, Per Johan Noren, and Oscar's three brothers, Harry, Walter, and Tom.

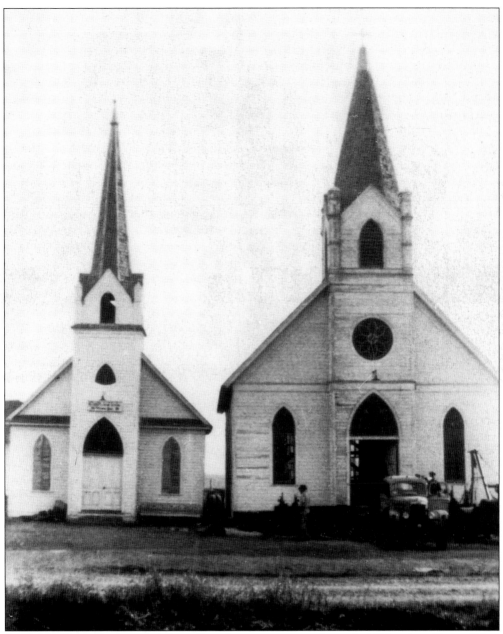

Settled by Swiss-German and Swiss-French immigrants in the early 1890s, the village of New Bern was named for Bern, Switzerland. In 1892, Ludwig Fuessel built St. John Lutheran Church (left) on land donated by Daniel Murphy. The building hosted a school for children and German and English classes for adults in addition to religious services. Soon afterward, Friedrich and Anna Stauffer donated land for the New Bern Cemetery. In 1912, a new, bigger church (right) was constructed by the Krieg, Stauffer, Caninenberg, and Bachman families, who provided much of the man power. The nearby community of Wuthrich Hill had a Lutheran church as well (the Evangelical Lutheran St. James Congregation), and in 1948, the two congregations merged. The 1912 church from New Bern was moved to Wuthrich Hill and renamed Prince of Peace Lutheran Church.

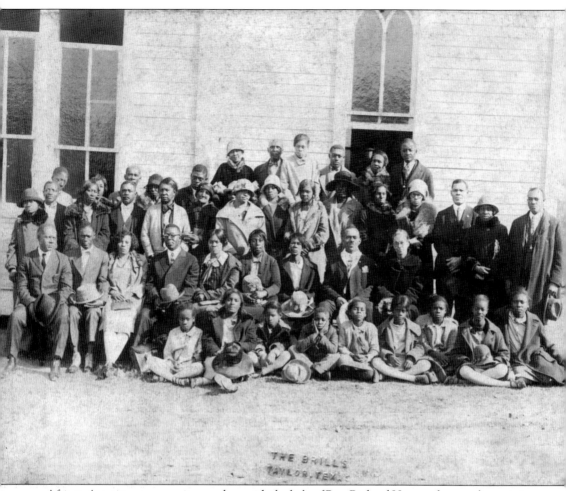

THE BRILLS
TAYLOR, TEX.

African American community members with the help of Rev. Richard Haywood, a traveling minister to the Austin area, established the Wesley Chapel AME congregation in 1869. The first church services were held under an arbor on land across the street from the church's present location. In 1881, trustees of the church paid $15 for the site of the first small, wood-frame church building. Soon, the congregation had outgrown its space. Church members built the current church in 1904 under the direction of pastor Rev. J. A. Jones, presiding elder Rev. J. W. Watson, and Bishop Evan Tyree. In order to raise money for the new building, Mrs. J. A. Jones, the pastor's wife, organized a children's Nail Club, which made and sold various items to the public, raising enough money to purchase all the nails necessary for the building's construction. This image from the 1920s shows the Wesley Chapel AME Church, located at 508 West Fourth Street in Georgetown.

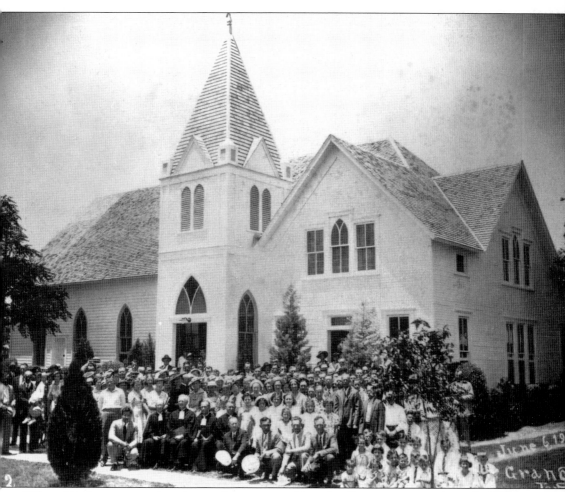

When Czech protestant immigrants began to settle in the Granger area in the early 1880s, they held their religious services in a schoolhouse. Early worship services were sporadic, as the congregation had to wait for a traveling preacher to arrive in town. In 1892, Rev. Adolph Chlumsky, a Czech Brethren minister based out of Brenham, helped interested congregants organize the church in Granger. Chlumsky's happy followers elected him their first pastor, and he commuted from Brenham to Granger for 18 years. By 1901, the number of parishioners had grown, and they constructed a church building. The Evangelical Unity of the Czech-Moravian Brethren in North America was officially organized under Chlumsky. In many Brethren churches, services were held in the Czech language until the 1940s. This image shows the Granger Brethren Church and congregation around 1938.

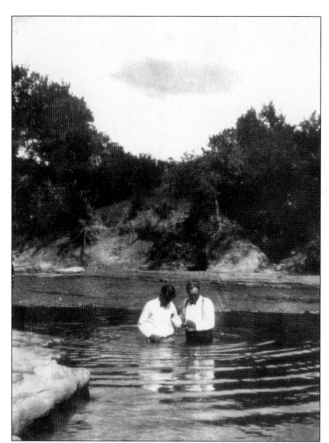

Congregations from denominations that believed in full-immersion baptism often held baptismal ceremonies in one of the county's many rivers or streams. In the left image, Pastor Franklin Baker baptizes Bethel Baker in the San Gabriel River in the 1920s. The image below shows a large congregation of worshippers in the river at Gabriel Mills near Andice.

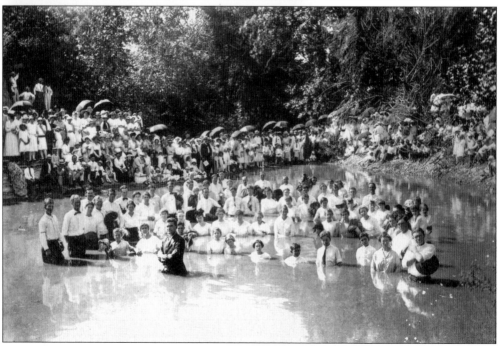

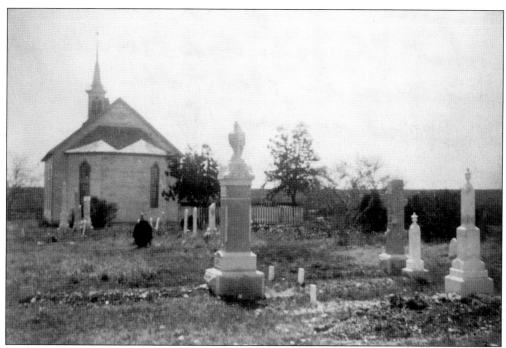

Swedish settlers organized the precursor to St. John's United Methodist Church, the Swedish Methodist-Episcopal Brushy Church, in 1882 with services held in private homes. In 1893, the congregation constructed the first church building (above) with a cemetery located nearby. The church purchased a plot of land in Georgetown in 1902 and constructed the new stone-clad building located at 311 East University Avenue. This image shows the first St. John's church building and cemetery. While the building no longer stands, the cemetery remains.

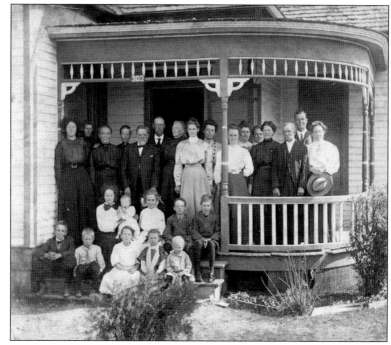

One of the earliest outreaches of St. John's United Methodist Church was the Ladies' Aid Society. In 1940, the group became the Women's Society of Christian Service. This image, taken around 1907, shows a Ladies' Aid Society social gathering. Sixteen adults and 10 children pose on the front porch of a house located at 303 East Sixth Street in Georgetown.

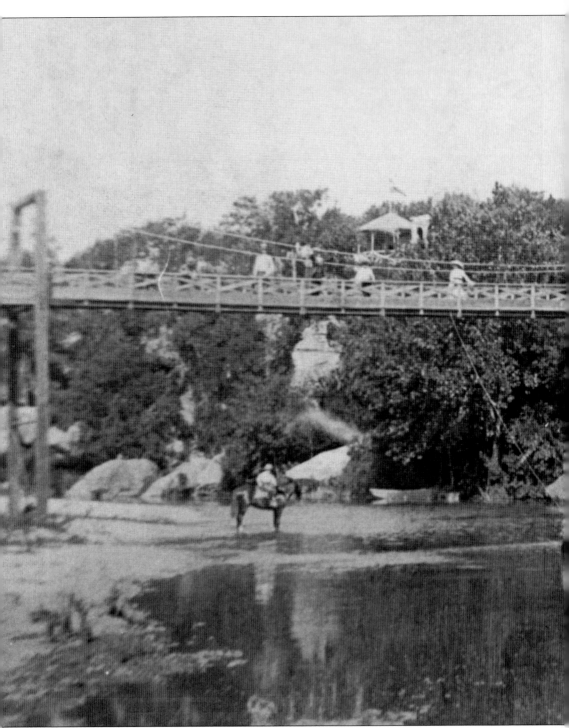

Chautauqua assemblies started in the late 1800s and spread throughout rural America until the 1920s. The assemblies featured speakers, teachers, entertainers, and preachers. A Chautauqua was established in Georgetown in 1888 and registered with the state. Every year, four-week summer programs brought nationally known figures to Georgetown. The local assembly boasted a large

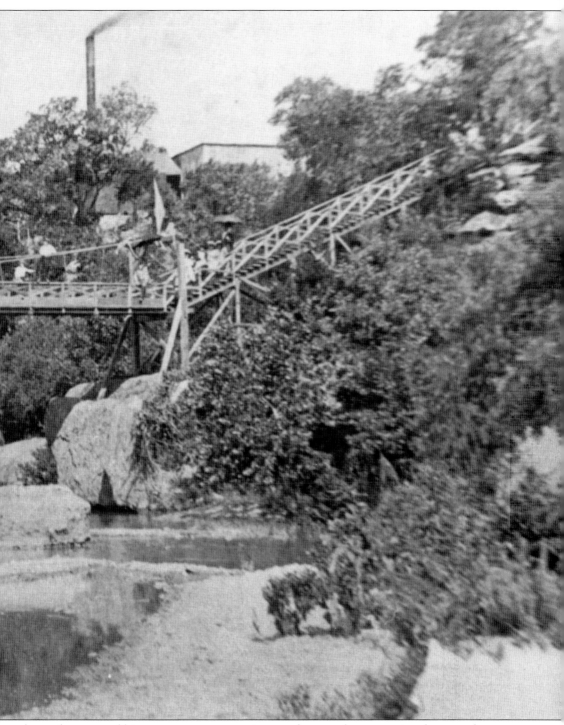

tabernacle, a natural history museum, concession stands, space for campers, and summer homes. This undated photograph shows the suspension bridge leading across the San Gabriel River to the assembly grounds in the background. The bridge was later washed away in a flood.

German-Wendish immigrants started arriving in Williamson County in the late 1870s. Settling in the community of Concordia (now Walburg), a group of citizens formed the Zion Evangelical Lutheran Church and set about establishing a place of worship, a school, and a cemetery. The first church was built on land purchased from Victor Schmidt and completed in September 1882. As the congregation grew, parishioners built additions to the church, but eventually they needed to construct a new building. By January 1901, after a year of planning, $1,500 had been pledged towards construction of the new church. The church's cornerstone was laid in April 1901, and the new building was dedicated for use in September of the same year. This undated photograph shows the second Zion Lutheran Church. Once this building was completed, members razed the old church and used the lumber to build a schoolhouse. In 1956, as the congregation continued to grow, Zion Lutheran Church constructed its third church building, which still stands today.

This image shows the young men and women of a 1911 confirmation class at Zion Lutheran Church in Walburg. Seated from left to right are (first row) Esther Hanusc Schneider, Emma Domasaschke, Maria Doering Leschber, and Leona Andres; (second row) Hulda Kalmbach, Ella Kokel Teinart, Pastor J. H. Sieck, Selma Mersiovsky Schwausch, and Emma Achulze; (third row) Ben Sieck, Albert Teinart, F. R. Leschber, John Jeske, and Edward Kalmbach.

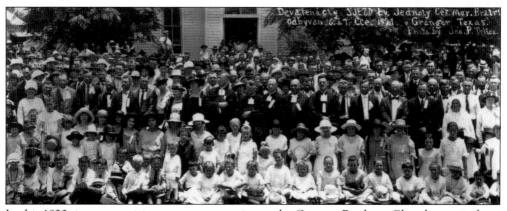

In this 1920s image, participants at a convention at the Granger Brethren Church pose in front of the church building. Granger Brethren Church is one of a number of congregations in Texas that make up the Unity of the Brethren Church, a name adopted in 1959.

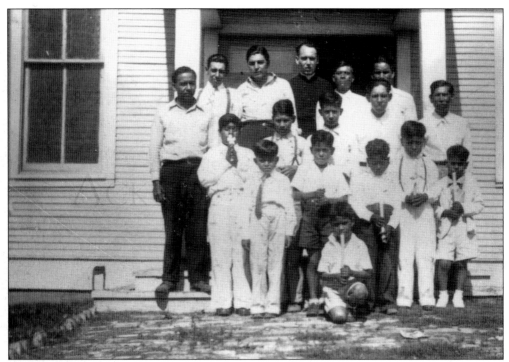

The Our Lady of Guadalupe Church was established in Taylor in 1914. This photograph, taken around 1936, shows the boys' First Holy Communion class. The young men in this photograph include, in no particular order, Rafael Martinez, Louis Reyes, Julian Perez, Fr. Lorenzo Ferrarro, Rafael Torres, Panche Mata, Beto Velasques, and Ruben Basulto.

The maypole is an old Germanic ritual practiced to celebrate May Day or Midsummer. This 1940s image shows members of the Zion Lutheran Church in Walburg, a German community in Williamson County, practicing the maypole drill. Posing from left to right are Tillie Schneider, Hildegard Domel, Alice Domel, Ruby Zoch, Gladys ? (in back), Beatrice Doering, Clarence Mertink, Calvin Kelm, Lambert Schneider, and Gus Schneider.

Swedish immigrants in the farming community of Hutto established the Swedish Evangelical Lutheran Church in 1892. Today it is known as the Hutto Lutheran Church. The first church building was constructed in 1893 on the site where the Hutto Co-op gin now stands. In 1894, however, a tornado destroyed the church. Immediately the members salvaged what they could from the ruins and began to construct a new church building on the same lot. By 1900, the congregation had outgrown their home, and they elected to sell their church and locate a lot for a new one. Members paid $225 for the new site, which is where the current church stands. A dedication service for the newly built Hutto Lutheran Church was held in July 1902. This c. 1944 image shows students from the church's Sunday school class at a picnic on the Gattis gravel bar on the San Gabriel River, just east of Jonah. Larry Rydell sits second from the left, and Rodney Johnson sits to his immediate right.

The African Methodist Episcopal (AME) Church got its start in the United States in late 1700s. It was the first African American denomination organized and incorporated in the United States. This portrait shows John and Fannie Robinson, founding members of the AME Church in Taylor.

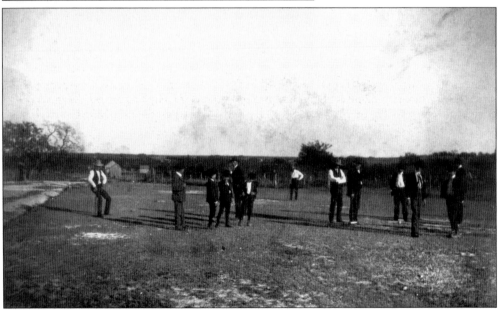

Most families in the area observed the Sabbath on Sundays, refraining from work on that day. This meant that after Sunday morning worship services, the rest of the day was left open for recreation. In this photograph, a group is playing Sunday afternoon croquet at the Kasperik farm near Walburg, still wearing their Sunday best.

Seven

HISTORICAL PEOPLE, PLACES, AND EVENTS

Williamson County enjoys a rich heritage filled with memorable characters and compelling stories. Unfortunately, many of them left little in the way of a physical record. As the county's population has soared in recent decades, much of this unique past seems to have been forgotten, except for the occasional roadside marker on a busy county roadway.

It is important to remember where we came from. Fortunately, some of the area's past was captured in vivid detail through county records, correspondence, and photographs, many of them housed in Georgetown's Williamson Museum.

This final chapter is devoted to remembering the rivers, roadways, cattle drives, oil booms, pioneers, and crusaders that have shaped the physical and cultural landscape of today's Williamson County.

It would be difficult to find a family that had a more active role in the development of Texas than the Berrys. John Berry (left) was one of the earliest settlers in Williamson County, arriving in 1846. On a spring (now the site of Berry Springs Park and Preserve in Georgetown), the Berry family established their home, farm, blacksmith and gun shop, and spring-driven mill. Hannah Berry (below), John's third wife, was especially instrumental in making the family's mill and farm a success. The Berry progeny included 18 children and 100 grandchildren. John Berry's oldest sons were Texas Rangers and soldiers for the Republic of Texas and Battle of Plum Creek; five sons served in the Confederate army. One notable descendant, a great-grandson, is Audie Murphy, America's most decorated soldier.

The first Williamson County commissioners' court met under a large oak tree in May 1848 with the task of establishing a county seat. This meeting site is now known as Founder's Park, on Ninth and Church Streets in Georgetown. Local lore tells that one day, George Washington Glasscock (right) rode up on a mule, and Washington Anderson greeted him with an offer: if Glasscock donated the land spanning from his family's oak tree to the San Gabriel River for a town site, the Williamson County Court would name the town in his honor. While it is true that Glasscock and business partner Thomas B. Huling did donate close to 173 acres for the county seat, it is more likely that Glasscock himself initiated the deal. Below is a presidential pardon for Glasscock's participation with the Confederacy during the Civil War, signed by Pres. Andrew Johnson.

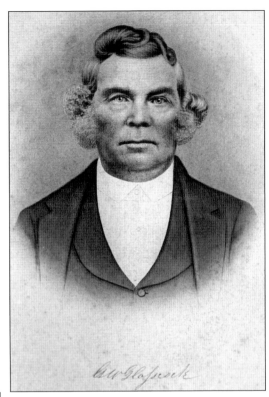

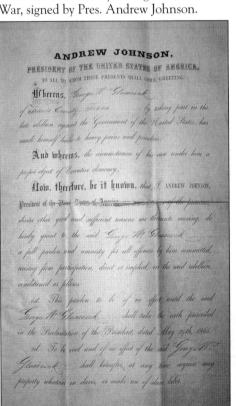

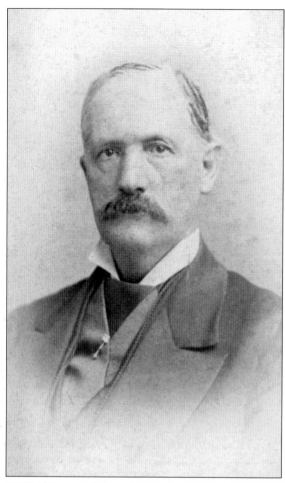

Thomas Proctor Hughes moved to Williamson County in 1851, where he practiced law and served as a county representative during the Secession Convention on the eve of the Civil War. An ardent Unionist, Hughes was one of only eight (out of around 175 total) delegates to vote against the Ordinance of Secession at the Texas convention. The ordinance required a popular vote to formally determine Texas's course, and Hughes and five other delegates spent the next three weeks campaigning against secession throughout Williamson, Milam, and Travis Counties. As a result of Hughes's work, Williamson County was one of only 18 Texas counties (of 122) to carry an anti-secession majority. After serving in the Confederacy during the war, Hughes helped organize Georgetown College, which later became Southwestern University. In 1872, he was elected district attorney for Williamson, Burnet, Llano, San Saba, Brown, and Lampasas Counties. Below is an image from a George Washington–themed reception held at the Hughes home in 1889.

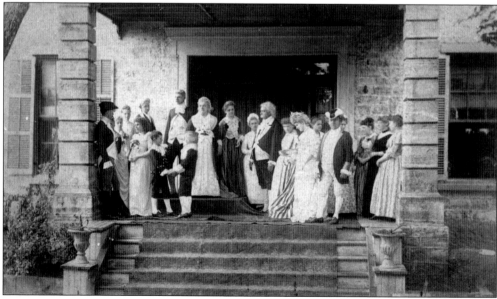

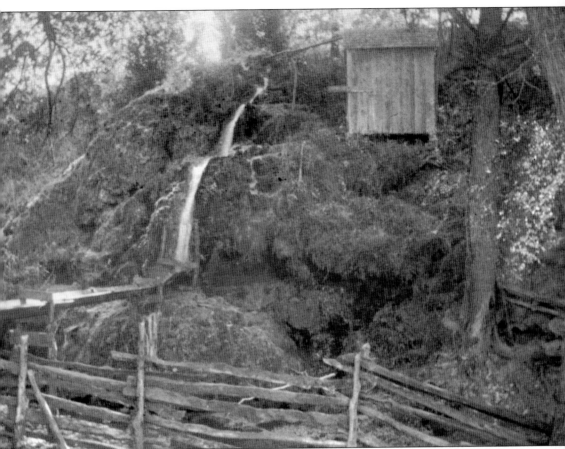

Shortly after the inception of Williamson County, John Owen and Benjamin Gooch constructed a flour mill west of Georgetown on the North San Gabriel River. They completed the mill and had it running by 1855. James Knight, the namesake of Knight Springs, purchased the site in January 1879. By the early 1880s, Knight had established an irrigation system and a successful strawberry garden, believed to be the first of its kind in the county. Ownership of the springs changed through the years, and both the Crockett family and the Redard brothers operated vegetable gardens at the site. Later the site was known as Crockett Gardens. Today the public can access the springs from the Good Water Loop of the San Gabriel River Trail on Lake Georgetown. The area, shown above in 1902, is noted for beautiful scenery, which includes a spring-fed waterfall, high cliffs with ferns and seeping springs, and ruins from the old mill.

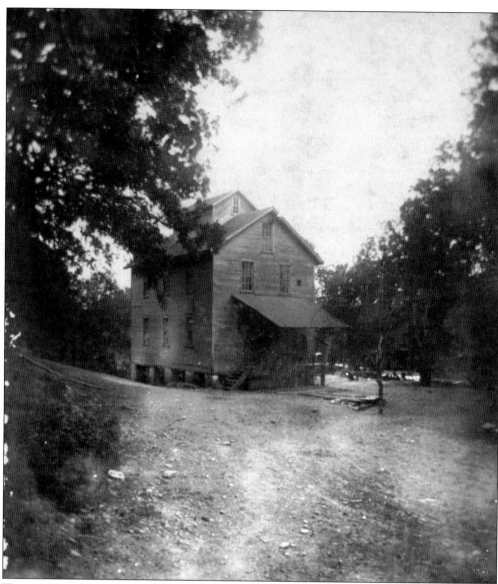

Towns Mill is shown in this 1898 image. Robert W. Towns and his brother James established a large milling operation on the east bank of the San Gabriel River in the 1870s. The brothers wisely constructed the mill at the site where the Double File Trail crossed the river, proving to be a high traffic area. The area near the crossing was known as Prairie Springs and Buffalo Springs because it served as a watering hole for local wildlife. The brothers established a successful gin and blacksmith shop at Towns Mill, and James Towns became first postmaster of Townsville in 1895. The community was short-lived—the Granger–Georgetown railroad line bypassed Townsville and resulted in the establishment of Weir in 1903. Operation of the mill continued, and Missouri, Kansas, and Texas Railroad officials began promoting the body of water formed by Towns Mill dam as a destination for camping, fishing, and boating, naming it Katy Lake. In 1913, a flood severely damaged the railroad bridge and destroyed most of Townsville's structures, including the mill.

This image shows Mamie Whittenberg (left) and Annie Whittenberg (right) enjoying an evening at the San Gabriel River on July 6, 1902. An important feature of Williamson County, the San Gabriel River has provided generations of the area's inhabitants with water and recreation, and the river's plentiful fish, game, and resources continue to attract people today. In 1716, the Ramon expedition named the river Rio de San Francisco Xavier, but an 1828 map mislabeled the river "San Javriel," which led to the present spelling of the river's name. The river flows east through Williamson County, joining with the middle and south forks in Georgetown. No matter what they have called it, residents of Williamson County have always enjoyed the opportunity and livelihood offered by the San Gabriel River.

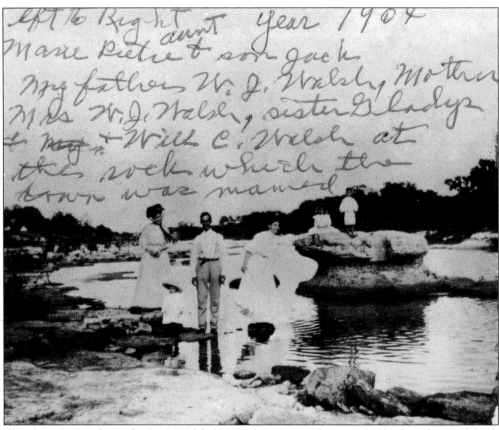

Left to Right Year 1904
Marie Pietre & aunt
& son gack
My father W. J. Walsh, Mother
Mrs W. J. Walsh, sister Gladys
& my & Will C. Walsh at
this rock which the
town was named

The above image shows the W. J. Walsh family enjoying an afternoon at the famed Round Rock on Brushy Creek in 1904. The Round Rock, one of the most well-known geographic features in Williamson County, is located in the center of Brushy Creek in Round Rock. The town, originally named Brushy because of its close proximity to the water source, was renamed Round Rock on August 24, 1854. According to *Land of Good Water*, Thomas C. Oatts, then postmaster, suggested the new name because of the many enjoyable hours he spent fishing with early pioneering settler Jacob M. Harrell from the anvil-shaped rock. The Round Rock marked a major low-water crossing on Brushy Creek for wagons and countless cattle drives.

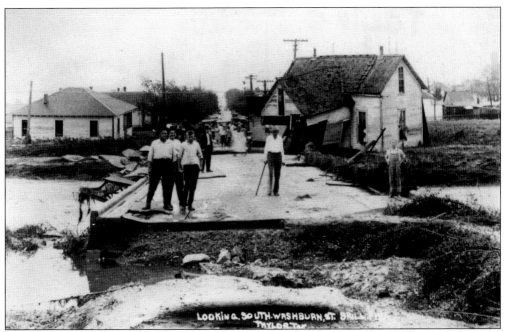

LOOKING SOUTH WASHBURN ST. [illegible]
TAYLOR TX

Williamson County is known for its scenic rivers and abundant sources of water, but these givers of life can be unpredictable and deadly. Flooding repeatedly devastated towns along the San Gabriel River until the U.S. Corps of Engineers constructed a series of dams and lakes in the 1970s to protect county residents and provide dependable sources of water. The September 1921 flood engulfed homes and swept away an entire section of Washburn Street in Taylor, as shown above. Taylor saw over 23 inches of rain during this flooding episode. Thrall saw an astonishing 38.21 inches of rainfall on September 8 and 9, 1921. The photograph below shows uprooted trees left in the wake of an April 1957 flood on the San Gabriel River.

As early as 1936, the Brazos River Conservation and Reclamation District announced plans to survey the north and south forks of the San Gabriel River in Williamson County to determine potential dam and lake sites. Construction of the dams finally started in 1972. The 36-year delay resulted from an initial lack of funding, debates on the proper location of the dams, opposition from area residents over the concern of lost farmland, and objections from conservationists. The U.S. Corps of Engineers completed Laneport Dam and Granger Lake, shown above and below, in the early 1970s. The site of the agricultural-based community of Allison, later known as Friendship, is now located beneath the waters of the lake. After the dam's completion, most of the former residents left the Friendship area, moving to other communities in Williamson County. The burials from the Allison (Old Friendship) Cemetery were relocated to nearby cemeteries in Granger.

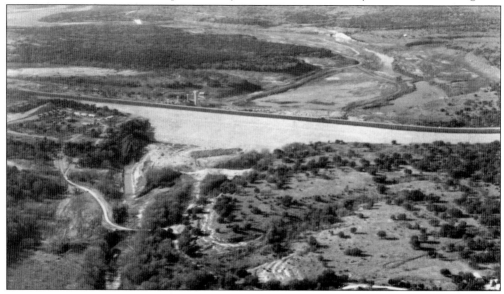

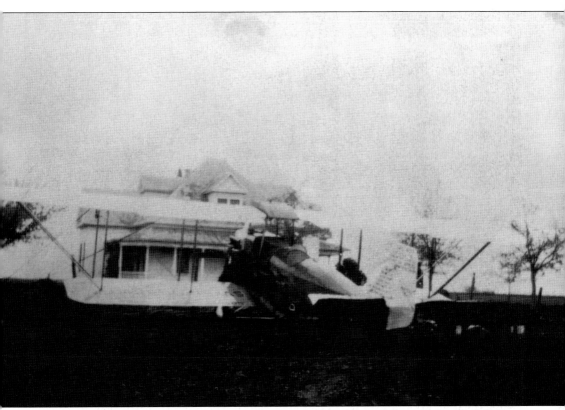

This photograph shows a barnstormer airplane parked in front of the Gunnar Rydell farm northwest of Taylor in the 1920s. After World War I, the U.S. government sold off a large portion of its surplus material, including a number of Curtiss JN-4 airplanes, called Jennys. These Jennys (for which the government had paid $5,000 when new) were sold for as little as a couple hundred dollars to servicemen and other individuals. As a result, barnstorming, a form of entertainment where pilots performed aerial stunts for the public, was born. Barnstorming events kicked off when pilots flew low over rural communities dropping advertising handbills to attract attention. From there, the pilots worked out a deal with a local farmer to use his property as a runway for the show, and spectators were charged admission. Barnstorming was popular until the late 1920s, when new flight safety regulations were enacted.

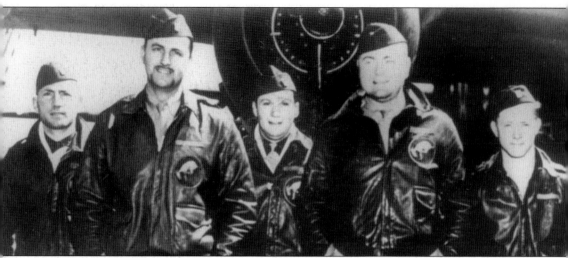

Taylor's Ross Wilder, shown above second from right, flew with Jimmy Doolittle's raiders in the April 18, 1942, raid on Japan during World War II. Lt. Col. James H. Doolittle led this raid, reaching targets in Tokyo and Nagoya. The attack was staged from the deck of the U.S. aircraft carrier *Hornet*. Earlier, Gen. Henry H. Arnold assigned Doolittle the task of assembling and training a group to fly B-25 medium-sized bombers to targets over 400 miles away in Japan. The B-25s could carry a large bomb load, take flight from an aircraft carrier at sea, and hold enough fuel to get the pilots to safety, making the aircraft ideal weapons for a surprise strike. There were 16 bombers in all, each with a specially trained five-man crew. During the course of the raid, Japanese forces captured eight of the American airmen, three of whom were executed. The success of the daring raid proved to be a morale booster for the American and Allied forces. Upon returning to Williamson County, Ross Wilder was hailed as a hero.

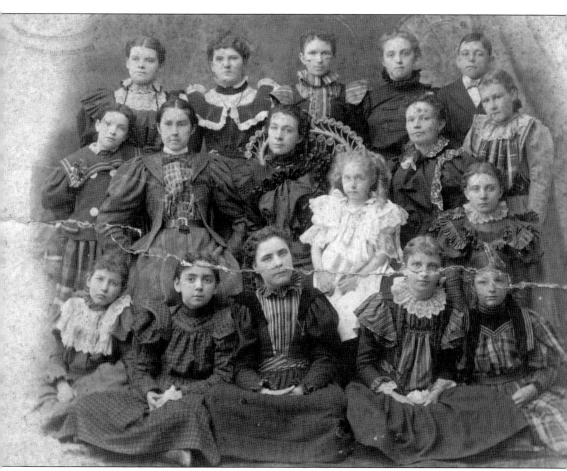

The above image shows a class of Georgetown students from about 1890. From left to right are (first row) Bess Carothers, Mittie Hutton, Beatrice Gee, Mary Mann, and Fay Tinnin; (second row) Tommy Nichols and Estelle Byrom; (third row) Louise Belford, Kate Tatom, Nannie Gee, Mrs. J. D. Elliott, and Beth Morrow; (fourth row) Annie Purl, Jessie Williams, May Teager, Anna Keaney, and Hays Gee. Annie Purl, valedictorian and member of the first graduating class of Georgetown High School in 1892, went on to graduate from Southwestern University with honors and teach at the Georgetown Grammar School for 50 years. Purl's lifelong career as an educator began when she was just 19. In 1948, a grammar school was renamed Annie Purl Elementary in her honor. Purl passed away in January 1961 and was interred in the Independent Order of Odd Fellows Cemetery in Georgetown. The cornerstone of the old grammar school building, recovered when the structure was torn down, marks her grave and pays tribute to Annie Purl's substantial contributions to education in Georgetown.

At the age of 19, Harry Graves was admitted to the bar. He left Williamson County to practice law but eventually returned, and his work here propelled him to the Texas House of Representatives and Texas Court of Criminal Appeals. In 1898, Graves was elected Georgetown's city attorney. He went on to practice law with D. W. Wilcox and served three terms as Williamson County attorney. While serving in that capacity, Graves was an integral member of the prosecuting team that was the first to publicly face and convict the resurgent Ku Klux Klan in a court of law in the early 1920s. Later Graves, with the support of Gov. Dan Moody, wrote the bill establishing the Texas Highway Patrol to help address the increasing traffic on Texas's inadequate and poorly maintained roads. Graves's insight led to the eventual formation of the Texas Department of Public Safety and a safe and organized state highway system.

Grocery List

The Old Faithful oil well in Thrall is shown at right around 1915. Although mostly known as a rural farming and ranching community, Thrall experienced an oil boom from 1915 through 1920. The first of many oil wells was drilled on the Fritz Fuchs family farm just south of Thrall in February 1915. When the Fuchs' well proved to be productive, the sleepy community doubled in population almost overnight. Farmers leased their land to oil speculators who, over the next five years, drilled close to 200 wells. The photograph below shows a productive field of Colwell Oil Company wells around 1920.

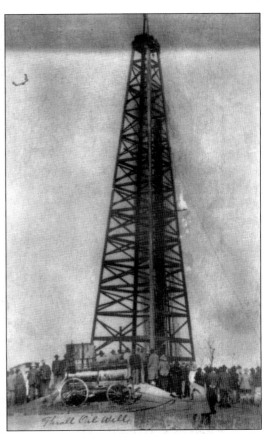

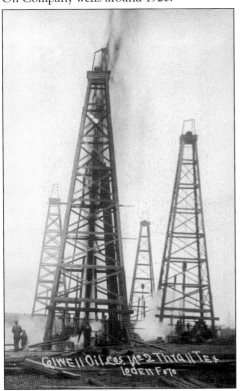

Dr. James Lee Dickey moved to Taylor with his wife, Magnolia Fowler Dickey, in the 1920s to practice medicine. Dickey was the only African American doctor in the community, replacing John K. Moore, who left to practice medicine in San Antonio. Dickey was dedicated to enhancing the quality of life of Taylor's African Americans, as illustrated by his campaign to improve the local water supply in the early 1930s, which halted a deadly outbreak of typhoid fever. Dickey's clinic (below) served Taylor residents and individuals from surrounding areas regardless of race. Dickey was nominated Man of the Year in 1952 by the Taylor Chamber of Commerce for his work in promoting better public health, housing, and education. His accomplishments were featured in the October 24, 1953, issue of the *Saturday Evening Post*.

Born in Taylor in 1893, Dan Moody attended the University of Texas (1910–1914), where he turned his focus to studying law. He was admitted to the bar in 1914 and returned to his hometown to practice law. Moody served in World War I and in 1920 began a career of public service. After he and his Williamson County legal team successfully prosecuted members of the Ku Klux Klan in the infamous 1920s Burleson flogging case, Moody became the youngest person elected to a number of public offices, including Williamson County attorney (1920–1922), district attorney of the 26th Judicial District (1922–1925), Texas attorney general (1925–1927), and governor of Texas (1927–1931). As governor, Moody focused on reform and fighting the culture of corruption previously established by the administrations of Governors James and Miriam ("Ma") Ferguson. In his crusade to expose corruption, Moody restored confidence in the Texas government by recovering huge sums of public money. Upon his death in 1966, Moody was buried in Texas State Cemetery in Austin.

Jessie Daniel came to Georgetown with her family in 1893 and graduated from Southwestern University in 1902. She married Roger Post Ames, a surgeon, whom she met in Laredo. Her husband died in 1914 and upon returning to Georgetown, the recently widowed Ames joined the Texas Equal Suffrage Association, dedicated to obtaining equal rights for women. She also served as the first president of the Texas League of Women Voters from 1919 until 1924. Up to this time, she worked with her mother, J. M. Daniel, who owned the Georgetown Telephone Company. This position with the telephone company proved crucial in helping Ames successfully organize over 3,000 women to register to vote at the Williamson County Courthouse in 1918. Ames later moved to Georgia in the 1930s, where she formed the Association of Southern Women for the Prevention of Lynching. She returned to Texas later in life and upon her death in 1972 was interred in the Georgetown International Order of Odd Fellows Cemetery.

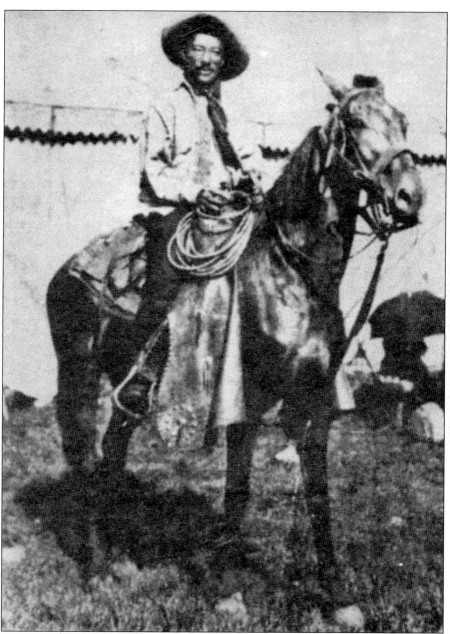

The son of former slaves, William "Bill" Pickett was born around 1870 in the Jenks Branch area, south of Liberty Hill. One of 13 siblings, Pickett started his career as a cowboy after completing the fifth grade. He went on to become the first African American inducted into the National Cowboy Hall of Fame. Pickett is credited with inventing "bulldogging," a form of steer wrestling. Pickett gave a performance of this technique at the first fair in Taylor in 1888. Pickett perfected his roping and riding skills and eventually traveled as a competitor in rodeos throughout Texas and Oklahoma. At that time, African Americans were not allowed to compete against white rodeo contestants, so Pickett billed himself as Native American, becoming known to many as the "Dusky Demon." In 1932, Pickett's career was cut short when he died after being kicked by a horse. His friend, humorist Will Rogers, announced the death of the rodeo star on his radio show.

Born in Georgia, Robert McAlpin Williamson (c. 1804–1859) came to Texas in the late 1820s and served as a Texas Ranger, lawyer, and judge. Because an illness at the age of 15 had caused his right leg to draw up permanently at a 90-degree angle, Williamson wore a wooden leg attached to the knee of the affected leg—leading to the affectionate nickname "Three-legged Willie." Despite his encumbrance, Williamson rode with William H. Smith's cavalry and fought at the Battle of San Jacinto. After being appointed by the Republic of Texas to organize the first three companies of Texas Rangers, Williamson went on to sit as judge of the Third District Court and as a member of the Supreme Court of the Republic of Texas. Williamson was elected to both the House of Representatives and the Senate of the Republic. After statehood, when the citizens of western Milam County petitioned to separate as a new county, Williamson's fellow senators rejected the suggested names "Clear Water" and "San Gabriel" and suggested instead that the new county be named in Williamson's honor. Although Williamson did not live in the area, he had traveled through the county as a circuit judge. This photograph shows a copy of artist F. de Gissaac's oil painting of Williamson at the Williamson Museum, the original of which hangs in the Texas State Senate Chamber. It was dedicated on San Jacinto Day in 1891.

Thomas Edward Nelson (1888–1951) was born on the Nelson family farm north of Round Rock. His parents, Andrew J. and Hedvig Nelson, emigrated from Sweden in the 1850s. Nelson graduated from the University of Texas and went on to serve as an officer in the U.S. Army. Nelson founded the Farmers State Bank and, in partnership with his brother Carl A. Nelson, started the Round Rock Cheese Company.

Swedish immigrant Andrew J. Palm settled near Round Rock with his mother and his five brothers in 1853. A community sprang up around the Palm family farm and the area became known as Palm Valley. Palm purchased land from immigration agent S. M. Swenson and constructed a home for his family—wife Carolina Nelson Palm and their eight children. The Palm house is now located at 208 East Main Street in Round Rock.

BIBLIOGRAPHY

Allen, Martha Mitten, ed. *Georgetown's Yesteryears*, series. Georgetown, TX: Georgetown Heritage Society, 1985.

Farney, Marsha. *Promoting the Progress of Education: The History of Georgetown Public Schools, 1850–1966*. University of Texas at Austin: Doctoral Dissertation, 2007.

Gattis, C. M., ed. *Jonah Reunion*. Jonah, TX: self-published, 1971.

Hall, Jacqueline Dowd. *Revolt Against Chivalry: Jessie Daniel Ames and the Women's Campaign Against Lynching*. New York: Columbia University Press, 1979.

Kirby, Jack Temple. *Rural Worlds Lost: The American South 1920–1960*. Baton Rouge: Louisiana State University Press, 1987.

Mantor, Ruth. *Our Town: Taylor*. Taylor, TX: self-published, 1983.

Parker, Martin. *Round Rock Texas, USA!!!* Round Rock and Wolfe City, TX: Sweet Publishing Company and Henington Publishing Company, 1972.

Scarbrough, Clara Stearns. *Land of Good Water, Takachue Pouetsu: A Williamson County, Texas, History*. Georgetown, TX: Williamson County Sun Publishers, 1973.

Shroyer, Jean and Hazel Hood, eds. *Williamson County, Texas: Its History and Its People*. Austin: Nortex Press, 1985.

Stratton, Brad; Christy Friend; Birdie Shanklin; Ethel Moore; and Martha Tanksley, eds. *Histories of Pride: Thirteen Pioneers Who Shaped Georgetown's African American Community*. Georgetown, TX: City of Georgetown, 1993.

Texas Historical Commission. Texas Historic Sites Atlas. http://atlas.thc.state.tx.us

Texas State Historical Association. Handbook of Texas Online. http://www.tshaonline.org

Walker, Tommy S. *Jonah, Texas: Fires, Floods, Friends and Kin*. Jonah, TX: self-published, 2004.

Williamson County Historical Commission. Historical Marker Application Files. Georgetown, TX.

The Williamson Museum. Research Files. Georgetown, Texas.

INDEX

Andice, 27, 45, 55, 80, 96
Bagdad, 23, 86
Bartlett, 20, 67
Beaukiss, 72
Cedar Park, 19
Circleville, 46, 47
Corn Hill, 7, 19, 67, 69
Coupland, 19, 69
Florence, 28, 44, 45, 69, 90
Frame Switch, 8
Georgetown, 2, 7–10, 16, 19–21, 25, 30, 32, 33, 36, 37, 69, 70, 72, 74, 78, 79, 82, 84, 91, 94, 97–99, 106–111, 117, 118, 122
Granger, 8, 19, 26, 29, 38, 43, 46, 47, 51, 53, 58, 66, 68, 69, 73, 79, 81, 83, 88, 89, 95, 101, 110, 114
Hare, 72
Jarrell, 69, 78
Jollyville, 85
Jonah, 32, 46, 52, 53, 58, 61, 63, 79, 103
Leander, 7, 22, 23, 69, 73, 86

Liberty Hill, 31, 34, 69, 77, 78, 96, 123
Machu, 8
Monodale, 8
Mozo, 8, 19
New Bern, 8, 93
Noack, 72
Pond Springs, 85
Round Rock, 7, 19, 20, 30, 40, 41, 60, 62, 69, 71, 72, 85, 92, 112, 125
Sandoval, 8, 72
Schwertner, 50, 67
Silent Grove, 78
Structure, 72
Taylor, 8, 19, 26, 29, 38, 57, 59, 69, 74, 75, 79, 88, 102, 103, 113, 115, 116, 120, 123
Theon, 8
Thrall, 8, 24, 39, 59, 69, 72, 80, 113, 119
Walburg, 8, 19, 24, 35, 50, 52, 69, 76, 100–102, 104
Weir, 19, 110

www.arcadiapublishing.com

Discover books about the town where you grew up, the cities where your friends and families live, the town where your parents met, or even that retirement spot you've been dreaming about. Our Web site provides history lovers with exclusive deals, advanced notification about new titles, e-mail alerts of author events, and much more.

MADE IN THE USA

Arcadia Publishing, the leading local history publisher in the United States, is committed to making history accessible and meaningful through publishing books that celebrate and preserve the heritage of America's people and places. Consistent with our mission to preserve history on a local level, this book was printed in South Carolina on American-made paper and manufactured entirely in the United States.

This book carries the accredited Forest Stewardship Council (FSC) label and is printed on 100 percent FSC-certified paper. Products carrying the FSC label are independently certified to assure consumers that they come from forests that are managed to meet the social, economic, and ecological needs of present and future generations.

FSC
Mixed Sources
Product group from well-managed forests and other controlled sources

Cert no. SW-COC-001530
www.fsc.org
© 1996 Forest Stewardship Council

Find Your Place in History.